THE CIRCLE AND THE LINE

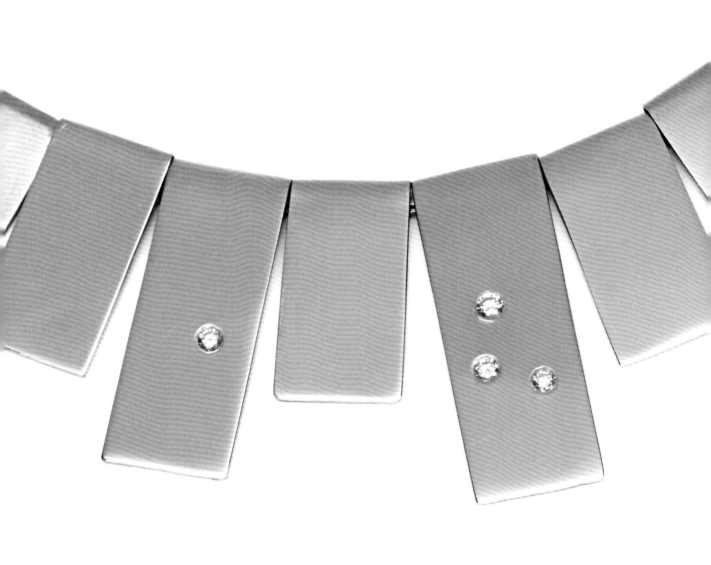

The Circle and the Line

THE JEWELRY OF BETTY COOKE

Jeannine Falino

Edited by Eleanor Hughes

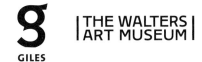

GILES

THE WALTERS
ART MUSEUM

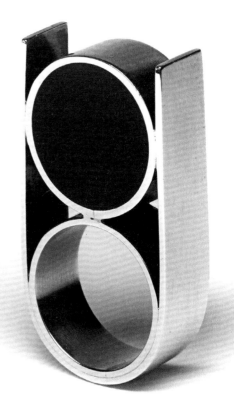

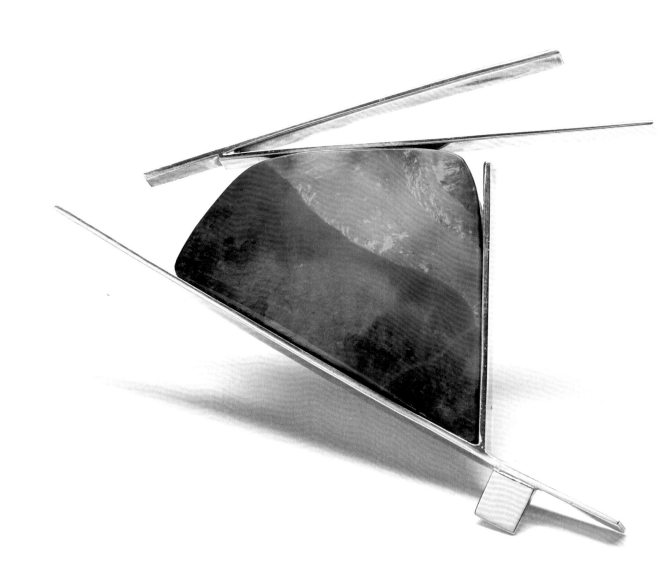

Director's Foreword

Betty Cooke has long been recognized as one of the foremost designers of modernist jewelry in America. Honored with numerous awards, her sought-after works have entered both museums and private collections. Over a career spanning more than seventy years, she has approached design with an elegantly spare aesthetic, focused on jewelry but also touching graphics, leatherwork, and, with her late husband William Steinmetz, interior design.

Although the Walters Art Museum holds no collections of modernist art, it is nevertheless a fitting venue for the first major museum retrospective of Cooke's career as a jewelry artist. A Baltimore native, Cooke recalls visiting the Walters as a child—she was ten years old when the museum first opened to the public in 1934—and cites several objects on display as having been part of her visual memory ever since. Truly a great Baltimore artist, Betty Cooke found lifelong inspiration in this great Baltimore collection. The museum's stunning holdings of historic jewelry, spanning seven millennia, are world renowned. It is worth noting that Henry Walters, one of its founders, was an avid collector of contemporary jewelry in his lifetime, buying aggressively at World's Fairs and the most fashionable commercial houses, such as New York's Tiffany & Co. and Fabergé in St. Petersburg, Russia.

As spectacular and clearly inspirational such a robust collection of jewelry at the Walters may be, the art of jewelry, however, has long been relegated to the margins of artistic importance, historically set apart from, and even outside of, the normative and evaluative categories of "great art," which were almost always restricted to painting and sculpture. Jewelry is often defined in museum collections as "decorative art" or even "craft," both terms that belie not only the

preciousness and integrity of the materials used in making excellent jewelry but also—and more importantly—the incredible skill and genius of the artists who design and create it. Among the most obvious reasons for jewelry's relegation to a status below that of "fine art" are, firstly, the historically collaborative nature of its creation (potentially involving different designers, specialists, and fabricators), making it difficult to ascribe to the singular notion of artistic genius so prized by art institutions, dealers, and consumers; and, secondly, especially since the nineteenth century, the perception and promotion of jewelry as a deeply feminized art.

Although headlined in the Western tradition by male artists since the ascendency of the goldsmiths in the middle ages, the art of jewelry—from design to market—has depended heavily on women as specialized artists, muses, models, patrons, and consumers. Artists like Louis Comfort Tiffany and René Lalique, for example, depended on an immediately identifiable design aesthetic particular to their brand, and yet the works they created (such as Lalique's famed *Orchid Comb* in the Walters collection) reflected the interests and inspirations of the women for whom they were made, many of whom commissioned the works themselves for personal wear. Like Tiffany and Lalique, Cooke is a singular genius whose art depends on

a signature "look" and on deeply sustained relationships, both with the materials she uses and with the patrons, recipients, and wearers of her work. Perhaps less concerned with crafting wearable tokens of power and conspicuous wealth, Cooke's artistry seems rooted in a relationship between abstract form and body: the capacity for a piece of jewelry to interact with the wearer's body rather than simply be displayed upon it. This exhibition and book reveal the deceptive simplicity of Cooke's work and its material and human connections—a current interest of the Walters as we reconsider objects in the collection not just as exemplars of craftsmanship and artistry but also as vehicles for telling stories that connect people across time. Cooke fuses materials ranging from the exquisite to the uncanny, melding forms and function through a powerful, iconic simplicity of design. Most of all, however, her jewelry embodies human connection; her designs connect people, as the testimonials from friends and clients included in this catalog reveal.

This book and the exhibition it accompanies explore not only the range and beauty of Betty Cooke's designs, but also the human connections intrinsic to those designs. These strands are woven together through the photography, essays, and recollections in this book. Guest curator Jeannine Falino, in her biographical essay, provides an overview

of Cooke's career and practice while placing her work in the context of her American design contemporaries. In addition to her distinguished career as a decorative arts curator, Falino has known and worked with Cooke for over a decade; we are truly grateful for her tireless work on this project, which could not have been accomplished without her vision and expertise. No strangers to the process, the curators were awed by the outpouring of support and enthusiasm of the many people who shared their collections of Betty Cooke jewelry and their individual stories of Betty herself as they selected works for the exhibition. We are keenly aware that when museums borrow works of art, we are asking for beloved objects; in this instance, we thank the museums who have lent treasures from their collections, and we especially wish to acknowledge the incredible generosity of those individuals who have parted with the necklaces, rings, bracelets, pins, earrings, and cufflinks that play intimate roles in their daily lives. We also owe a debt of gratitude to the individuals who have expressed their thoughts about Betty and her work in the form of the Reflections included in this book. Special thanks are due to Fred Lazarus, President Emeritus of the Maryland Institute College of Art, who has been a guiding light and continual support in this project, long in the making. We also extend many thanks to

those whose financial support has made this exhibition and book possible.

Most of all, of course, our deepest gratitude and appreciation must go to Betty herself and, posthumously, to her husband Bill. While many artists and designers of their generation sold work privately or through galleries, Cooke and Steinmetz stood virtually alone in their class as artist-entrepreneurs whose thriving business—The Store Ltd— always amplified the pursuit of Betty Cooke's exceptional artistic practice. For this and so many reasons, Baltimore and the Walters Art Museum are privileged to honor Betty Cooke, her career, and, most of all, her incredible art, which she has bestowed for posterity on Baltimore and beyond.

Julia Marciari-Alexander
Andrea B. and John H. Laporte Director
The Walters Art Museum

Curatorial Acknowledgments

I seems that the stars were particularly well aligned in our preparations for this project: many talented individuals came together to make this exhibition and publication possible. I am deeply grateful to Julia Marciari-Alexander, Andrea B. and John H. Laporte Director of the Walters Art Museum, for her invitation to serve as guest curator. While every staff member at the museum has in some way contributed to the success of the project, I owe special thanks to the brilliant team led by Eleanor (Ellie) Hughes, Deputy Director for Art & Program, in particular Ruth Bowler, Director of Imaging, Intellectual Property, and Publications, and Jenn Harr, Head of Collections Management. Walters Senior Photographer Ariel Tabritha is responsible for the spectacular images that illustrate this book. I am grateful to Ocky Murray for its glorious design and to Sam Mera-Candedo for the beautiful design of the exhibition.

Research was conducted at several institutions with the assistance of key staff. For their efforts, grateful thanks are extended to Beth Goodrich, Librarian, American Craft Council; Laura MacNewman, Associate Archivist, Cranbrook Archives; Christine B. Peterson, Associate Vice President for Enrollment Services, and David Bogen, Vice President for Academic Affairs and Provost, Maryland Institute College of Art; Elisabeth Thomas, Assistant Archivist, and Christina Eliopoulos, Archives Fellow for Research and Reference, Museum of Modern Art; Joseph King, Director of Registration, and Jill Vuchetich, Archivist, Head of Archives + Library, Walker Art Center; Timothy J. Thomas, Senior Vice President, Baltimore Sun Media, Gail Brett Levine, Executive Director, National Association of Jewelry Appraisers, and Ariana Bishop, Curatorial Research Associate for Jewelry, Museum of Fine Arts, Boston. In

California, I was assisted by Julie Muniz, independent curator, Palo Alto, and Rosa Novak, researcher with the Brian and Edith Heath Foundation in Sausalito.

At the Baltimore Museum of Art, I would like to thank Virginia M. G. Anderson, Curator of American Art and Department Head, and Sarah H. Cho, Curatorial Assistant, American Painting & Sculpture and Decorative Arts, and Andaleeb Badiee Banta, Senior Curator of Prints, Drawings and Photographs and Department Head, and Curatorial Assistant Morgan Dowty; at the Museum of Fine Arts, Boston, Emily Stoehrer; at the Cooper Hewitt, Smithsonian Design Museum: Caroline Baumann, former Director, and Yao-Fen You, Senior Curator and Head of Product Design and Decorative Arts Department, and Associate Curator Cynthia Trope; and at Cranbrook Art Museum, Andrew Blauvelt, Director, and Corey Gross, Registrar.

In Baltimore I had the privilege of meeting many people who count themselves among Betty Cooke's delightful orbit of friends and collectors, and who stepped forward to offer their assistance. First and foremost, I offer special thanks to Fred Lazarus, President Emeritus of the Maryland Institute College of Art (MICA), Nancy Rome, and filmmaker and MICA faculty member Allen Moore. To the dozens of jewelry collectors and friends of Betty who opened their homes to us, you have my deep appreciation for your generosity of spirit and your willingness to share treasures. Betty's loyal staff at The Store Ltd and her personal assistants deserve considerable credit for their countless acts of kindness and consideration during my many visits to The Village of Cross Keys.

Yvonne Markowitz, Curator Emerita, Museum of Fine Arts, Boston, and Elyse Karlin, who are co-directors of the Association for the Study of Jewelry and Related Arts, offered helpful comments along the way. My husband, David Heath, who makes all things possible, was my stalwart support.

It was a great privilege to meet Betty Cooke and Bill Steinmetz in 2006 in preparation for the exhibition *Crafting Modernism: Midcentury American Art and Design* (Museum of Arts and Design, New York, 2011), and to inventory Betty's personal jewelry collection, a process that began in 2016. Over the years I came to appreciate the talent, drive, and high standards that have been key to her success over so many decades. It is my hope that this retrospective exhibition resonates with some of Betty's creative energy and affirms the limitless possibilities of good design.

Jeannine Falino

Reflection

Ellen Lupton

Betty Cooke and William O. Steinmetz Chair in Design
Maryland Institute College of Art

Senior Curator of Contemporary Design
Cooper Hewitt, Smithsonian Design Museum

A line of gold meets a dot of pearl. Straight lines form a curve. Flat discs grow along a stem. A black stone skims the edge of an open spiral. A curving row of half-circles becomes an abstracted wreath or ruffle. Every piece in Betty Cooke's astonishing body of work has a clear, intentional structure. Every piece produces a decisive rhythm or a relationship among lines, shapes, volumes, and materials. This is design.

In the fall of 2019, I had dinner with Betty and the typeface designer Tobias Frere-Jones, who had just delivered a public lecture at MICA about his work. Typeface design is a subtle art—so subtle, it nearly becomes invisible. Tobias's numerals for the Wall Street Journal *line up in neat columns and stay crisp at tiny sizes. We see the numbers but not the font— which is the whole point. At dinner, I wanted to show Tobias the work of Betty Cooke, so I took off my necklace and laid it down on a bright linen napkin. A short choker, the piece is built from five thin tubes of gold. The tubes are threaded together like beads, and between each tube is a row of pearls.*

The lengths of gold are bent into shallow curves, following the natural drape of the pearls.

It's iambic pentameter for a woman's throat—gold pauses, pearls for emphasis. Endings matter, too. The clasp of this necklace consists of a closed circle and a flat disc—elements that appear throughout Betty's work as both active ornaments and functional clasps.

"This necklace is like typography," I told Tobias. It's a unique sentence written in a universal syntax. A line of type is a series of separate marks that meld together in the mind. The style and spacing of the strokes hold the text together. Indents, italics, and shifts in weight shatter the monotony. Sometimes, there's a headline—a chunk of resin, a block of quartz, or a polished piece of ebony. Sometimes, all that's needed is a well-wrought line.

A few years ago, Betty made for me a pair of earrings that are simply loops of wire bent into long, oddly shaped ovals, forming primitive closures. Once, I lost one of these earrings and came to her asking for a replacement. "Why don't you just bend the wire yourself?" she asked, slightly annoyed to be troubled with this task. After all, I was the careless one who had lost the earring, and anyone can bend a piece of wire, can't they? I begged her to help me anyway, and she did.

Jewelry can be heavy—a symbol of marriage ties, secret memberships, and military might. It can also be playful, light, and ephemeral. Some of Betty's works of art are easy to wear, while others demand courage and trust. Jewelry is a gentle form

of bondage. It circles the throat, cuffs the wrist, or lays claim to a finger. My favorite Betty pieces will always be the chokers. In the twenty-four years I have known her, I have carried her gold sentences around my neck nearly every day. The simplest neckpiece is nothing more than a golden wire bent into eight straight segments. (I would make one myself, but I couldn't.) One choker features nine small gold discs, each connected at a single point to a straight gold line; magically, these flat little circles become flowers. Another necklace is nearly the same but adorned with squares instead of circles. The squares are just squares—they don't need to be anything else. All of these pieces are too special to save for special occasions. They mark my daily reality, like perfect pages of Garamond.

Johannes Gutenberg, who invented printing with metal type, was a goldsmith and a gem cutter. Sequoyah, who designed a syllabary for the Cherokee language, was a silversmith and a blacksmith. Metalwork and typography are sister psyches. Jewelry designers create "settings" for stones, while typographers "set type," composing characters into lines of text. A setting is a framework, a surround. It frames, underscores, illuminates, and punctuates. Betty's work is a setting for life. Each piece catches light and frames the body. Each piece is a profound lesson in how to see.

Less Is More

JEANNINE FALINO

When I taught, we used to study what can be done with one straight line. I can spend years with a circle. If you have the ideas and the materials, the results are limitless.

Betty Cooke

T he circle and the line are two elementary forms of composition. For Betty Cooke, they are the irreducible components of good design. Her guiding principle of "less is more" has led to an acclaimed body of monumental, wearable minimalist sculpture made throughout more than seventy years of artistic practice.

In all its variety, Betty Cooke's jewelry is instantly recognizable, characterized by a consistency of approach to form and materials. As Cooke herself says, "the real success of this jewelry is that you can do something that is very simple . . . that's attractive and different."[1] Expressed through lines and angles, with swooping and orbital forms like boomerangs and stretched circles that appear to hurtle through space like celestial bodies, the feeling is always gestural, and the motion—the sensibility—is always modern.

Whether alone or assembled in small groups, Cooke's work has a dynamic asymmetry, balanced by a gestural line, or by placing a point of emphasis in the form of a stone, a disc, or a shift in material or texture. Many of her works, particularly her rings, take full advantage of three-dimensional design, using discs arrayed in space as planar elements. Cooke's jewelry is made to move comfortably on the body and give pleasure to the wearer and viewer alike. Her materials range from humble to precious, including smooth pebbles, wood, natural crystals, and colorful gemstones, set sparingly in gold and silver.

Many of Cooke's most iconic designs are neckpieces, perhaps the most attractive form for jewelers as they offer the largest area of the body on which to express an idea. Cooke sometimes uses necklaces to expand upon ideas that she had previously experimented

Fig. 1
Neckpiece, ca. 1955, silver.
Collection of the artist
(cat. 30)

with in brooches or rings. This is true for her investigation of the circle, both in positive forms and negative spaces. Open circles, inscribed with wires, are as irresistible as the play of solid, flat discs arrayed about the neck (figs. 1 and 2). Early brooch experiments with pivoting elements seeded an idea that later grew into complex branching neckpieces. Cooke's interest in open outlined forms led to a group of arresting neckpieces, some composed of overlapping oval shapes and others appearing more like musical notations (fig. 2). A series of ray-like neckpieces, having slender fingers of gold and silver, and occasionally scattered with diamonds, have become another signature design.

Beginnings

Born and raised in Baltimore, Cooke made jewelry while attending the Maryland Institute of Art (now MICA) and Johns Hopkins University, where she obtained a BFA in Art Education in 1946.[2] She recalls visiting the Walters Art Gallery as a small child, perhaps even at or soon after its opening in 1934. Some of the works of art she saw there made impressions that have lasted her entire career, such as an ancient bronze mirror (fig. 3) and the combination of different-colored metals in suits of armor. Her original plan was to become a sculptor. She joined the Institute's faculty as an instructor of design and material, while working in her studio on painting, jewelry, and leatherwork. She briefly apprenticed with a jeweler who "made little flowers." Cooke enjoyed her time at the jeweler's bench and became convinced of the potential in this art form.[3]

Within a year of graduation, Cooke began to be recognized as a young artist worth watching. She participated in local exhibitions, garnering praise in 1947 for "a collection of simple massive silver ornaments" shown at a Baltimore crafts exhibition held at the Peale Museum (today's Baltimore City Life Museums). At a Baltimore Water Color Club exhibition, Cooke's work was said to attract almost as much attention as those by nationally ranked artists in the exhibition, including Milton Avery, Boardman Robinson, Millard Sheets, and John Whorf.[4]

Independent-minded and fearless by temperament, Cooke was ready to see the world upon graduation in 1946. During the summer of 1947, she and a friend hitchhiked to Nova Scotia, where they toured the landscape and camped outdoors until a forest fire nearly put an end to their adventure.[5] That close call, however, merely renewed her desire to see more of the country. Traveling was also a means to an end: she soon set off for California in an old car with a friend and a custom-made box containing examples of her jewelry to find new outlets for her work.

Each time they reached a stopping point, Cooke took her samples to design stores she admired. "In this way," Cooke recalled soon afterward, "I arranged to get distribution throughout the ... country."[6] She knew about the Walker Art Center in Minneapolis through its magazine, then called *Everyday Art Quarterly,* and its Bauhaus-educated curator, Hilde Reiss, and decided to visit the museum.[7] Her samples impressed Reiss, then at work on the landmark traveling exhibition *Modern Jewelry under Fifty Dollars*. Reiss immediately decided to include a silver-and-leather bracelet and a pair of earrings in the 1948 exhibition. Cooke recalls that silver and leather neckpieces were also shown.[8]

Cooke's jewelry was shown alongside works by Margaret De Patta, Harry Bertoia, Art Smith, and Claire Falkenstein, all well-respected studio jewelers with established national reputations.[9] At twenty-four years old, Cooke was attracting national attention for her reductive, elemental shapes, attuned to the modernist canon then informing all artistic disciplines. The exposure from the *Modern Jewelry* exhibition vaulted her to prominence, as reflected in articles published at the time. Some were written by women who, like Cooke, were entering the working world in greater numbers. As a young female metalsmith in the postwar era, Cooke benefited from the interest of these journalists who promoted her talents and offered frank

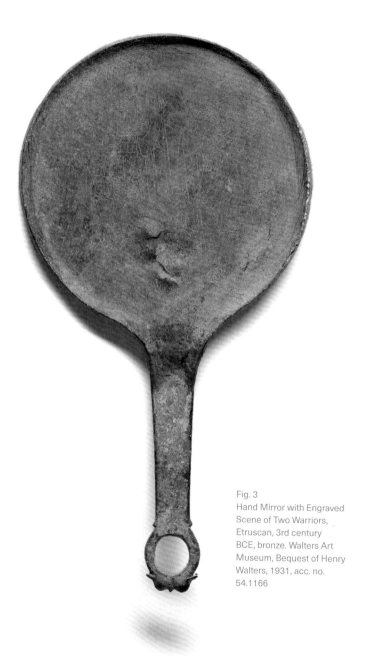

Fig. 3
Hand Mirror with Engraved Scene of Two Warriors, Etruscan, 3rd century BCE, bronze. Walters Art Museum, Bequest of Henry Walters, 1931, acc. no. 54.1166

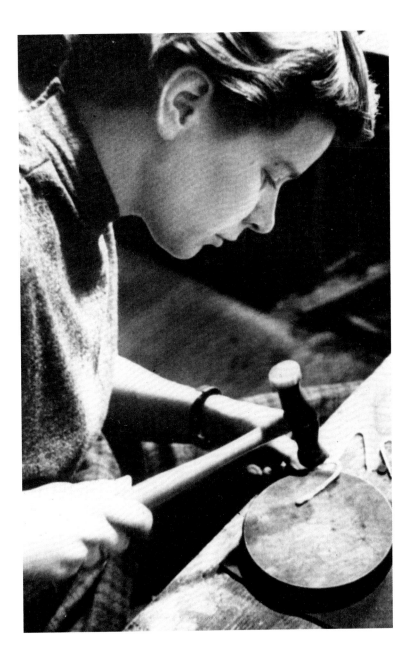

Fig. 4
Betty Cooke at work in her studio on Tyson Street, ca. 1947. Collection of the artist

admiration of her confident and assured manner—and self-sufficiency (fig. 4).[10]

Her jewelry captured the attention of the California avant-garde magazine *Arts & Architecture*, in which she stated, "Simplicity that creates a pleasure when a thing is seen in clear orderly design is neither cold nor impersonal. Then we have an ornament which is a thing in itself, adding quality to a costume instead of a confusion of vague gobs of gilt and glitter" (fig. 5).[11] Simplicity—"the thing in itself"—was her watchword. The jewelry's emphatic geometry, created through forging, sawing, soldering, finishing, and other techniques, is indicative of Cooke's

strong design sense and imaginative use of materials. She strengthened her metalworking skills in 1951 by taking a summer course in silversmithing at Cranbrook Academy of Art in Michigan, where she was taught by department head Richard Thomas.[12]

In 1947, Cooke purchased for $2,000 a dilapidated house in Baltimore at 903 Tyson Street, a narrow property "twelve feet wide and twenty deep" that dated to the 1830s. The small neighborhood, comprising two blocks of row houses, attracted artists and creative people like Cooke who restored the area and gave it a bohemian feel, contributing to its reputation as "Greenwich Village in

miniature."[13] She set up a studio at the rear of the first floor, while the front area served as a tiny gallery; upstairs were living quarters. She married fellow artist, designer, and teacher William O. (Bill) Steinmetz in 1955, and the couple eventually purchased adjacent 905 Tyson Street in order to expand their business.

As Cooke & Steinmetz, Designers and Consultants, the couple took on numerous design projects, including installation designs for the American Institute of Architects' centennial exhibition held at the National Gallery of Art in Washington.[14] Their interior work ranged from a unified design for the fifty Fair Lanes bowling alleys to ecclesiastical furnishings for a Pennsylvania church. A career-changing connection came with the patronage of pioneering urban planner and Baltimore developer James W. Rouse, who hired Cooke and her husband to create graphic materials and to serve as design and color consultants. Rouse commissioned Cooke to make a map of the city of Baltimore out of brass and bronze for his office and, for a new home, a pair of andirons.[15]

If the late 1940s marked Cooke's rapid entry into the public arena, in the 1950s she solidified her national reputation through participation in exhibitions around the country. Her entrance was well-timed: the concept of artist- or designer-craftperson as an occupation was gaining traction. Whether self-supporting or working with commercial firms, these artists were imbuing industrially manufactured wares with a craft aesthetic. This midcentury trend was amplified by pioneering philanthropist Aileen Osborn Webb, who was the creative force behind the foundation of today's American Craft Council (ACC, formed in 1939 as the American Handicraft Council), its publication *Craft Horizons* (the only national publication of its type, later *American Craft*), America House (New York, 1940–71, the first national craft gallery), and the Museum of Contemporary Crafts (New York, 1956; today's Museum of Arts and Design).[16] These elements served as a professional scaffolding for aspiring craftspeople and designers to meet, interact, exhibit, and gain a foothold in their field. Women were well represented across all media, and many attended the School for American Craftsmen (est. 1944), also founded by Webb, where students received instruction in design, technique, and "market awareness."[17]

These activities were widely covered in *Craft Horizons*, and Cooke, a subscriber, was the kind of artist for whom the magazine, these organizations, and exhibitions were intended. The magazine mentioned her participation in early ACC exhibitions such as the 1951 edition of its well-known series *Young Americans*, with ornaments featuring strong contrasts between

silver and black plastic or patinated silver, and *From Rock to Beauty* (1952) on lapidary art in jewelry.[18] Cooke's jewelry and leather goods were shown at the prestigious Los Angeles County Fair (1951, 1952, and 1953), and the 1953 *Young Americans* exhibition, where she won third prize for a pin with reversible parts.[19] She was also represented in *Designer Craftsmen U.S.A. 1953*, the first major traveling exhibition organized by the ACC, with another reversible brooch that employed Plexiglas (fig. 6).[20] Embrace of the modern included new products like plastics, with which Cooke experimented in the 1950s. As she recalled, "Plexiglas was new, and of course a lot of people were [using] plastics of different sorts. I chose the black Plexiglas which I could sand and it wasn't shiny—it had a sort of matte finish. I could steel wool or matte it. And it reminded me a little of ebony, which I happened to love. You could do things with the Plexiglas that you couldn't with ebony" (fig. 7).[21]

She also created a set of expandable andirons—the same as those she made for Jim Rouse—which were included in *Good Design*, one of an influential series of exhibitions developed by Museum of Modern Art curator Edgar Kaufmann Jr., and held at Chicago's Merchandise Mart in 1954.[22] The andirons, an elegant composition of vertical brass rods set in horizontal iron supports, proved popular and were sold in New York City by Georg Jensen,

then the avatar of modern design.[23] For Cooke, acceptance into the *Good Design* show was thrilling. "You see, what was exciting then is that it was the beginning of what we called the Design Revolution . . . Herman Miller, Charles Eames—all these people were producing these wonderful things."[24]

Fig. 6 (left)
Pin, ca. 1951–53, silver and Plexiglas. Collection of Howard Auerbach and Ken Maffia (cat. 26)

Fig. 7 (right)
Pin, 1951, silver. Cranbrook Art Museum, Bloomfield Hills, Michigan, 1951.150 (cat. 25)

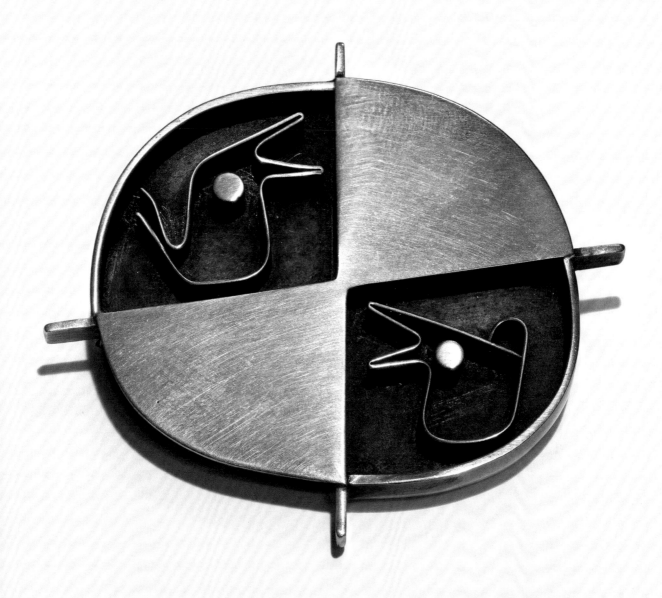

Fig. 8
Water Bird, ca. 1950, oil
on masonite. Collection of
The University of Arizona
Museum of Art, Tucson;
Gift of Edward Joseph
Gallagher, Jr. 1963.003.006

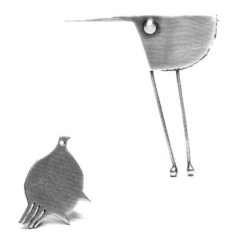

The angularity that characterized Cooke's designs was tempered by her love of nature, a subject close to her heart from childhood. Walks along the stream valley near her home instilled in her a particular affinity for waterways and forests. As a young artist, she often depicted water fowl and a variety of forest creatures in pen and ink, watercolor, and oil.[25] Cooke's flattened use of color and form in *Water Bird* (fig. 8) translated to designs on the jeweler's bench. In the 1940s and '50s she created a menagerie of birds and animals, working with thin sheets of silver and copper to capture their alert attitude and active stance. A related series of brooches of animals and other subjects were enlivened with colored enamels. The movement and wit

that Cooke conveyed in these tiny objects are leitmotifs that continued into her later abstract forms (fig. 9).

As Cooke's stature grew through exhibitions and publications, so too did demand for her work. She has been rightly acclaimed by art historian Toni Greenbaum as an "outstanding exemplar of the American limited-production jeweler."[26] As early as 1956 Cooke's approach to production was singled out by designer Don Wallance, whose landmark volume *Shaping America's Products* (1956) featured artists successfully navigating a world in which craft and design influenced production.[27] In his chapter on "the artist-craftsman as designer-producer," which addressed the challenges of scaling up studio production beyond the capacity of a single artist, Cooke was presented as a case study

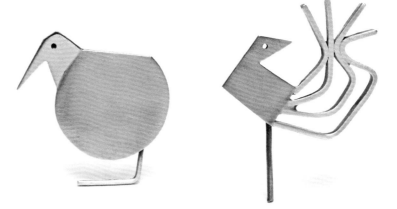

alongside prominent woodworkers, ceramists, and jewelers like George Nakashima, Wharton Esherick, Marguerite Wildenhain, and Margaret De Patta, all a generation older than Cooke. In contrast to the carefully planned and executed designs by De Patta, Wallance found Cooke's work imbued with "spontaneity, freshness, [and] individuality," traits he believed were a valuable antidote to the repetitive nature of mass production. He described her working method as quick and direct: "She records design ideas in very free sketch form and then executes the design directly in the required material. She does not like to fuss with a design. Although an idea may form in her mind over a period of time, the design in final form is very direct and freely executed. Often the first version is the final one."[28] This rapid, instinctive process has

remained a constant for the artist throughout her career.

In another measure of Cooke's rising reputation, her name and her designs began to appear in publications with broad national appeal. *Women's Day* magazine published her leather handbag and accessories designs for motivated readers to try out at home, and referring to her jewelry, named her "one of this country's most brilliant young artists."[29] Media-specific craft publications sought her out as well. D. Kenneth Winebrenner's influential *Jewelry Making as an Art Expression* (1953) and Lois E. Franke's *Handwrought Jewelry* (1962) each included examples of her work.[30] The most notable of these was a neckpiece having two descending, asymmetrical

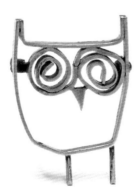

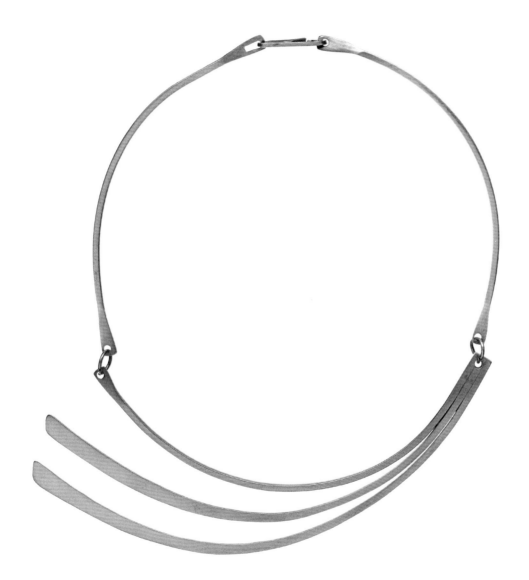

"fronds," or curves, whose controlled shape heralded her shift in the 1970s toward a broader gestural expression (fig. 10). These publications made her designs accessible to aspiring makers while expanding her status as an influential designer and craftsperson.

The Store Ltd

In 1965 Cooke and Steinmetz moved their growing business to Rouse's vibrant new shopping center, called The Village of Cross Keys, located in an affluent suburb near Baltimore's city limits. This mall was one of the first of Rouse's experiments in creating a community-centered design that attracted visitors who could enjoy nature and art while shopping; it was also a prototype for Rouse's vision for the city of Columbia, Maryland, one of a handful of planned communities in the nation.[31] The couple were among the founding tenants, and their shop, The Store Ltd, was located directly beneath Rouse's own offices. As Cooke recalled, "When we got something new and fun in, we'd take it outside in the court square. Jim would appear at his balcony."[32]

At The Store Ltd the couple created an airy, modern space with a modular design where they displayed Betty's jewelry, along with examples of "good" modern design, craft, folk art, and imported goods. This blend of design and handmade craft was one that Cooke and Steinmetz had long embraced and shared with leading midcentury advocates of contemporary design that they had followed from the start of their careers.[33] Industrial designers Ray and Charles Eames, for example, integrated aspects of the handmade in their furniture designs and Ray, in particular, arranged countless such materials within their rational, off-the-rack "kit-of-parts" California home.[34] It was also a defining feature of the Design Research (D/R) stores first established in Boston by Ben Thompson in 1953. Design Research sold paper lamps designed by Isamu Noguchi, introduced modern furniture classics by Alvar Aalto, Marcel Breuer, and Hans Wegner to American homes, and were the US distributors of Marimekko fabric and clothes. Their "humanizing" approach balanced rational, modernist design with warmth, personality, and color.[35]

Cooke and Steinmetz began buying Marimekko fabric and clothing from Design Research to sell at The Store Ltd. For their part, Thompson and his wife, Jane, featured Betty Cooke jewelry at Design Research in a sleek white display cabinet designed by Cooke and Steinmetz—one of two originally made for use in The Store Ltd. One approving critic noted that its design "makes standard display cases look like borax."[36] Early advertisements for The Store Ltd featured Bill's quick sketch of informally yet fashionably dressed women wearing Cooke's popular star earrings (fig. 11).

As Cooke continued to design jewelry into the late 1960s, her aesthetic began to shift. The new work was elegant and deceptively simple, and, as ever, true to her personal design compass. Her changes primarily involved the use of silver tubing and gold, along with more gestural forms. Most studio jewelers active in the 1950s and '60s worked in silver rather than gold and eschewed precious stones because their clientele held artistic expression in greater esteem than the intrinsic or material value of an object.[37] As a consequence, many studio jewelers avoided gold and diamonds, considering them to be the domain of commercial jewelers. Yet in time, and with the stability afforded by The Store Ltd's success, Cooke became one of those who turned to gold for its color. By the late 1960s or early '70s, Cooke began to offer customers her designs in sterling silver or 14-karat yellow gold.

In this period, Cooke also began looking for ways to create larger works with greater impact. She experimented with lightweight, slender tubes that she sourced from metal refiners and cut them to different lengths, assembling them in various combinations, adding "tassels," and threading them on nylon or plastic-coated thread.[38] The resulting necklaces weighed very little, and could be handled like delicate chains that could wrap and twist around the figure in innumerable

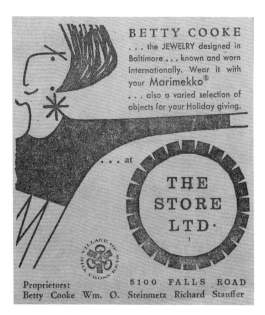

ways, creating unexpected angles that caught the light as the wearer moved (fig. 12). The tubes also prompted her to think differently about her compositions and inspired lyrical necklaces that featured sprays of shorter tubes resembling pine needles (fig. 13). Using the tubular necklaces as a base, she experimented with the infinite possibilities of what she calls "units"—such as metal discs and squares—that could be adapted and used in combination with other elements.

As Cooke taught her customers how to drape these new necklaces, their versatility

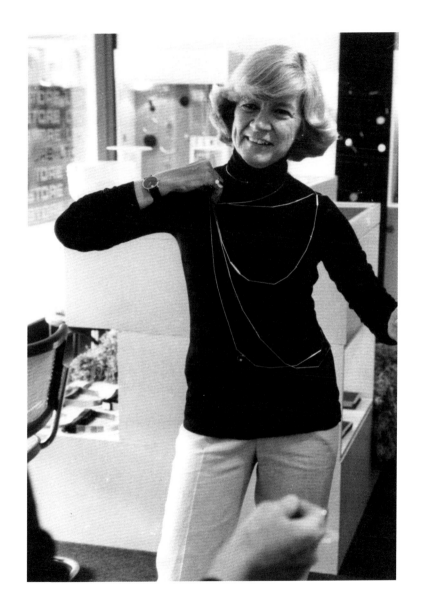

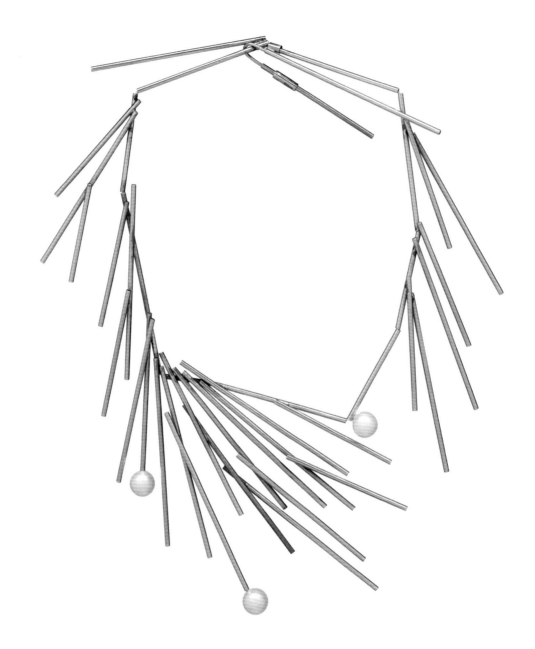

Fig. 13
Necklace, ca. 2012, gold
and pearls. Collection
of Berthe Hanover Ford
(cat. 143)

and beauty further expanded her reputation. The long tubular necklace has become one of her most enduring designs, one that can be endlessly modified and worn in different ways. Each one has a small disc bearing Cooke's maker's mark that is soldered to the side of a tube, a tiny but recognizable decorative element. Her combinations of pearls in long strands with tubes or interspersed with gold elements also became classics, updating the demure pearl necklace of old with a fresh and innovative look.

The tubular necklace, with its strikingly angular look and flexible arrangements, offered a new way to think about fashion as changeable, adaptable, and open-ended. Cooke herself has embodied this style by wearing simple garments that allow free movement, steering clear of fussy details, and serving as the perfect canvas for her jewelry, to the extent that many of her customers have emulated her fashion sense.

Although Cooke doesn't always work directly from sketches, drawing constitutes a key part of her practice as a way of expressing her thoughts and ideas. In the 1970s, the gestural aspect of her sketches was captured in a new kind of sculptural neckpiece that was forged from a solid piece of gold wire. These have a graceful form that resembles a line drawn freehand into a circular shape. They are direct descendants of her neckpieces

from the 1950s, but with more movement and open-ended termini. The new works were not hinged, but designed to be put on by simply flexing the metal. One such example, composed of two arcs of gold and a prominent diamond positioned near the throat, won the De Beers "Diamonds Today" award in 1979. Other examples make use of a second pivoting arc. Like the tubular necklace, the gestural neckpiece has countless variations and became a classic design. Cooke won the De Beers award again in 1981 with a very contemporary statement: a gold bracelet graced with a smooth beach pebble and a brilliant-cut diamond.[39] This delightfully unexpected combination proved that there was still a place for humble materials in modern jewelry (fig. 14).

Having created custom work for clients since the 1950s, Cooke has often been called upon to incorporate precious stones, including family diamonds, into her designs.[40] Custom jewelry work is an intimate affair, requiring faith in the ability of the artist matched by the artist's desire to create a pleasing work. For Cooke and some of her most ardent clients, this relationship has deepened over many decades and commissions.

In the late 1970s the fashion world came calling. Cooke's jewelry was featured on the Milan and New York runways and in *Vogue* magazine with clothes by Geoffrey Beene and

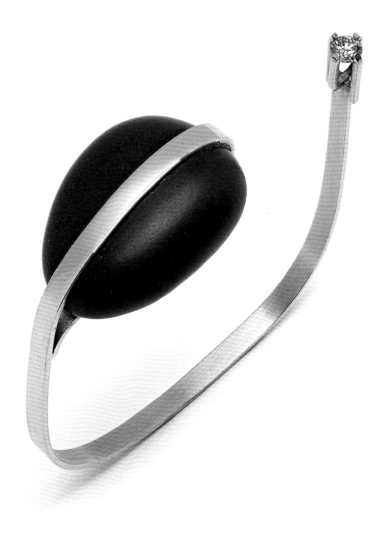

other designers.[41] Having an understanding of the role of drama and scale in fashion, Cooke created bold, assertive forms for this purpose: long pendants adorned with brightly colored glass, and chunky stones and crystals. One popular neckpiece was made of heavy-gauge tubing that crossed at the throat in a manner similar to the gesture-based necklaces, and terminated in large quartz crystals (cat. 94).[42]

These experiences led to further investigations with colored stones, especially unconventionally shaped cuts that could become a bright and colorful focal point. Among her favorites were rich and unusual opals, lapis lazuli, cool blue chrysoprase, rutilated quartz, watermelon tourmaline, and moonstones. Cooke began to offer her own suggestions to clients, some of whom assembled large collections of her jewelry. By the 1970s, according to Cooke's estimate, custom jewelry constituted a large percentage of her business.[43]

Many of Cooke's commissioned works offer eloquent proof that artists often surpass themselves in their desire to create exceptional works of art for special clients, as is the case for some of the examples found in this exhibition catalog. The warmth that develops between Cooke and her patrons has also led to an extraordinary number of commissions encoded with a private language—one that strangers would not

easily recognize, but shared by Cooke, her client, and their close family members. One of the remarkable examples was ordered by Jim Rouse for his second wife, Patricia "Patty" Traugott Rouse in the form of annual birthday and anniversary gifts. The jewelry was created over the course of two decades, beginning with their marriage in 1975. Each ornament has a unique design, with numbers cleverly disguised to mark a date or a year— for example, a brooch that bears the number 65 (if one knows how to look) or a neckpiece whose curves and two moonstones signify the number 68 (figs. 15 and 16).

Each of these commissions holds special meaning for the owner, and binds them even more firmly to the artist who is the conduit for their messages. Many owners wear their jewelry in public knowing these messages in plain sight are solely intended for their loved ones, as in the delightful gold-and-onyx suite made for one woman whose abstracted *B* signaled her familial name "Bubbe" (Yiddish for grandmother).

As Cooke has often stated, her great pleasure in working as a jeweler has been the community of collectors who have become friends as well as clients. Many have purchased jewelry over decades, passed treasured items on to their children, and even adopted a manner of dress inspired by their admiration for and friendship with the artist. A

Fig. 14
Bracelet, 1981, gold, diamond, and pebble. Collection of the artist (cat. 100)

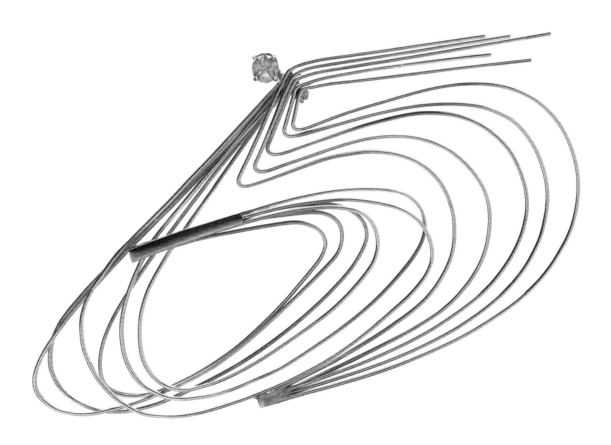

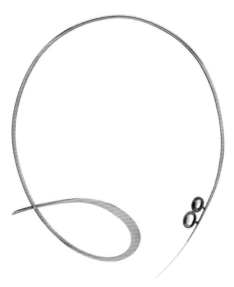

number of them hail from Baltimore's vibrant art and culture scene. Statements from some of her clients throughout this catalog testify to mutual bonds of trust and admiration.

When Betty Cooke burst upon the scene in 1947, she held a distinctly modern point of view that placed its faith in the promise and transformative power of good design that has, over many decades, kept her young at heart and her clients devoted. She has amassed legions of admirers in Baltimore and beyond, having ridden a midcentury revival wave that rediscovered her in the 1980s and has led to her inclusion in museum catalogs and exhibitions ever since.[44] Cooke reigns as a foremost symbol of contemporary style and craftsmanship and retains the same sense of optimism and excitement that she had as a young woman: "As I say, I'm always waiting for the surprise. I can't wait to come up with something that I've never done before. And it will be mine."[45]

Notes

1 J. Wynn Rousuck, "Jewelry," *Baltimore Sun*, December 8, 1974.

2 MICA is the acronym for the Maryland Institute College of Art. During Cooke's era, Johns Hopkins University was the degree-granting institution for those studying art education. Thanks to former MICA director Fred Lazarus for clarification.

3 The Maryland Institute School of Fine and Practical Art Day School, 1948–1949, Degree and Diploma Courses. Quotation from Rousuck, "Jewelry."

4 For jewelry, see Carol Wharton, "Exhibit Notes," *The Sun, Baltimore Sunday Morning*, November 16, 1947. For watercolors, see Carol Wharton, "Exhibit Notes," *The Sun, Baltimore Sunday Morning*, December 12, 1948.

5 "Maryland Hitch-Hikers See Lots of Maritimes: Spend Only $10 So Far," *Halifax* [Nova Scotia] *Herald*, August 12, 1947.

6 Quotation, Margot Doss, "Designing Young Woman," *Baltimore Sun*, October 23, 1949. According to the artist, by this date she was selling jewelry through galleries in Chicago, San Francisco, Los Angeles, Denver, Monterey (California), and Woodstock (Vermont). Jan Yager (oral history interview with Betty Cooke, July 1–2, 2004, Smithsonian Archives of American Art [hereafter "Yager, Cooke interview, AAA"]) asked Cooke about design magazines she owned from 1948 and found that the artist had checked a number of names of artists and design galleries that she planned to visit that year. For California, Cooke had checked Harry Bertoia, La Jolla; Claire Falkenstein, Berkeley; Keith Monroe, Sausalito; Caroline Rosene, Robert Kasper, and Pacific Shop, San Francisco. In Grosse Pointe, Michigan, she had marked Alexander Girard; in Chicago, Baldwin Kingrey, Inc.; and in New York City, New Design, Inc.

7 Reiss was educated as an architect and designer who immigrated to New York in 1933 and worked with such leading architects and designers as Russel Wright, Gilbert Rohde from Germany, and Norman Bel Geddes before arriving at the Walker Art Center. Alexandra Griffith Winton, "'A Man's House is His Art': The Walker Art Center's 'Idea House' Project and the Marketing of Domestic Design 1941–1947," *Journal of Design History* 17, no. 4 (2004): 48n.

8 Due to her late acceptance to the exhibition she was not listed in the publication "Modern Jewelry under Fifty Dollars," *Everyday Art Quarterly* 7 (Spring 1948). The show was circulated by the American Federation of Arts and opened in Baltimore, December 1949. There is a discrepancy between the artist's memory and the museum records: the registrar's records indicate that a bracelet and a pair of earrings were loaned to the exhibition, but Cooke recalls that more objects were shown. Correspondence, Joseph King, Director of Registration, Walker Art Center, January 4, 2019; Jill Vuchetich, Archivist, Head of Archives + Library, Walker Art Center, January 14, 2019.

9 The objects by Cooke from this exhibition do not survive.

10 Doss, "Designing Young Woman"; Carol Wharton, "Pathfinder in Jewelry," *Baltimore Sun*, December 4, 1949; Maria B. Wooden, "Teacher is Lured into Jewelry Designing," *Baltimore News-Post*, July 9, 1952.

11 Betty Cooke, "Jewelry Designed by Betty Cooke," *Arts & Architecture* 66, no. 4 (April 1949): 32; "Modern Jewelry under Fifty Dollars," *Baltimore Museum News* 13 (December 1949): 5–6; Wharton, "Pathfinder in Jewelry."

12 Cranbrook Academy of Art: Records of the Administration collection (1981-09 14:8).

13 Mildred Weiler Tyson, "Tyson Street Lures Artist-Designers," *Christian Science Monitor*, June 2, 1964.

14 Cooke & Steinmetz were exhibition designers for *One Hundred Years of Architecture in America*, May 15–July 14, 1957, organized by the American Institute of Architects, at the National Gallery of Art.

15 For more on Rouse and an illustration of the map, see James H. Bready, "America's Top Shop Center Developer," *Baltimore Sun*, May 5, 1963.

16 See "Webb, Aileen Clinton Hoadly (née Osborn; later Mrs. Vanderbilt Webb)" and "American Craft Council," in Jeannine Falino, ed., *Crafting Modernism: Midcentury American Art and Design* (New York: Abrams and Museum of Arts and Design, 2011), 316, 329.

17 "The School for American Craftsmen at the Rochester Institute of Technology" (advertisement), *Craft Horizons* 10, no. 4 (Winter 1950): 3; "School for American Craftsmen," in Falino, *Crafting Modernism*, 326.

18 "A Challenge to the Future: A Selection of Prize Winning Entries from the Annual Young Americans Competition, 1951," *Craft Horizons* 11, no. 3 (Autumn 1951): 34; "Exhibitions," *Craft Horizons* 12, no. 1 (January 1952): 47.

19 "Craft Show Ready at America House," *New York Times*, June 11, 1953. See Timeline for a list of exhibitions and awards.

20 Plexiglas is the trade name for an acrylic resin

made of methyl methacrylate polymers that was invented in 1933.

21 Gerald W. R. Ward, "Controlled Substances: The Mastery of Materials and Techniques by Studio Jewelers," in Kelly H. L'Ecuyer, *Jewelry by Artists in the Studio, 1940–2000* (Boston: Museum of Fine Arts, Boston, 2010), 213–14, 16n.

22 This exhibition was one of a series curated by Edward Kaufmann Jr. between 1950 and 1955 for the Museum of Modern Art, New York; many of the exhibitions were also mounted at the Chicago Merchandise Mart. Cooke exhibited a bell in 1951 and andirons in 1954, but these items do not appear in the publications.

23 Cynthia Kellogg, "Accessories Add Fireplace Cheer," *New York Times*, February 22, 1954.

24 Yager, Cooke interview, AAA.

25 Ibid. Cooke also credits her formative years as a Girl Scout and later as a counselor for her love of the outdoors and for the arts and crafts programs in which she participated.

26 Toni Greenbaum, "Betty Cooke," in Martin Eidelberg, ed., *Messengers of Modernism: American Studio Jewelry 1940–1960* (Montreal and Paris: Montreal Museum of Decorative Arts in association with Flammarion, 1996), 122–23.

27 Don Wallance, "Betty Cooke, Baltimore, Md.," in *Shaping America's Products* (New York: Reinhold Publishing Corporation, 1956), 162–63.

28 Ibid.

29 Quotation from "Collector's Craft Book: Sterling Silver Jewelry," *Woman's Day*, April 1958, 72–76. "The Smartest Leather Designs are the Simplest to Make," *Woman's Day*, February 1956, 78–83. *Woman's Day* magazine offered a booklet entitled "125 Gifts You Can Make Yourself" that listed Cooke as one of the designers; *Woman's Day*, November 1957, 25. The booklet itself does not identify Cooke by name, but the designs are the same. *Woman's Day Gift Book* (New York: Woman's Day, Inc., 1957), 29–31.

30 D. Kenneth Winebrenner, *Jewelry Making as an Art Expression* (Scranton, Pa.: International Textbook Company, 1953), figs. 261, 269, 329; Lois E. Franke's *Handwrought Jewelry* (Bloomington, Ill.: McKnight & McKnight, 1962), 18, 113, 125. See also Thomas Gentille, William Sayles, and Shirley Sayles, *Step-by-Step Jewelry: A Complete Introduction to the Craft of Jewelry* (New York: Golden Press, 1968), 64.

31 Jimmy Stamp, "James W. Rouse's Legacy of Better Living Through Design," *Smithsonian Magazine*, April 23, 2014, accessed January 8, 2020, www.smithsonianmag.com/history/james-w-rouses-legacy-better-living-through-design-180951187/.

32 Jacques Kelly, "A Lifelong Impact on Baltimore's Arts Scene," *Baltimore Sun*, February 7, 2015.

33 For example, in 1956 Cooke & Steinmetz designed the interior for Mischanton's restaurant in Eastpoint Shopping Center, Baltimore, which included furnishings by Ray and Charles Eames for Herman Miller.

34 In building their home, the Eameses employed many readily accessible and prefabricated elements "standard in the building industry but in many cases not standard to residential architecture"—in building their home. "Case Study House for 1949 Designed by Charles Eames," *Arts & Architecture* 66, no. 12 (December 1949): 26–39. The term "kit-of-parts" is often applied to their building method, for example in Donald Albrecht, *The Work of Charles and Ray Eames: A Legacy of Invention* (New York: Harry N. Abrams in association with the Library of Congress and Vitra Design Museum, 2005), 15, 25, 129.

35 Jane Thompson and Alexandra Lange, *Design Research: The Store That Brought Modern Living to American Homes* (San Francisco: Chronicle Books, 2010); Pat Kirkham, "Humanizing Modernism: The Crafts, 'Functioning Decoration,' and the Eameses," *Journal of Design History* 11, no. 1 (1998): 15–29. The same was true for Herman Miller's Textiles & Objects Gallery, which opened in New York City in 1961, featuring textile designs by Alexander Girard that contrasted with folk art.

36 Carol Cooper Garey, "Display," *Women's Wear Daily*, December 30, 1969, ill. The jewelry cabinet was one of two originally made for The Store Ltd. Thompson purchased one of these for his Cambridge, Massachusetts, shop.

37 Jeannine Falino, "Diamonds were the Badge of the Philistine: Art Jewelry at Midcentury," *Metalsmith* 31, no. 5 (2011): 46–53.

38 Yager, Cooke interview, AAA. Cooke purchased metal tubes from Hoover and Strong, Richmond, Virginia. Cooke believes she was among the first jewelers to use the tubes when they first became available in the 1970s.

39 Gabrielle Wise, "Designer Finds a Pot of Gold and Pebbles: Natural Materials, Free Forms Mark Betty Cooke's Work," *Baltimore Sun*, July 24, 1979; Ettagale Lauré, "1981 Diamonds Today: And the Winners are . . .," *Jewelers' Circular-Keystone*, August 1981, 167; 180, ill.

40 Doss, "Designing Young Woman."

41 Marcelle Sussman, "Fashions 81," *Baltimore Sun*, March 8, 1981. A neckpiece by Cooke appeared with a Roberta di Camerino blouse in "In Peru: Cool, Cooler, Coolest," *Vogue* 166, no. 5 (May 1, 1976): 161, fig. 13. A bolo tie with clothes designed by Bill Kaiserman appeared in "Everyone Wants a Jacket," *Vogue* 168, no. 9 (September 1, 1978): 490, 513.

42 For images of Cooke's designs for Beene clothing, see "Fitness Now!" *Vogue* 168, no. 7 (July 1, 1978): 117; "The New York Collections: The Clothes to Live in Now," *Vogue* 168, no. 9 (September 1, 1978): 420–21.

43 Rousuck, "Jewelry."

44 Renewed awareness of midcentury jewelry was sparked by *Structure and Ornament: American Modernist Jewelry 1940–1960* (New York: FIFTY–50, 1984). The catalog featured five examples by Cooke.

45 Yager, Cooke interview, AAA.

Timeline

Life events and exhibitions featuring
the work of Betty Cooke

1924	Born Catherine Elizabeth Cooke on May 5 in Baltimore, Maryland
1946	BFA in Art Education, Maryland Institute of Art (now MICA), with degree granted by Johns Hopkins University
1947	Purchases 903 Tyson Street, turning it into a gallery, studio, and residence
1948	*Modern Jewelry under Fifty Dollars*, Walker Art Center, Minneapolis; circulated by the American Federation of Arts to venues including the Baltimore Museum of Art (1949)
1951	*Young Americans 1951*, America House, New York, organized by the American Craftsmen's Educational Council
1951	*Arts and Crafts, Painting and Sculpture*, Los Angeles County Fair, Pomona: first and second prize for jewelry without stones, second prize for leathercraft
1951	*Alumni Textiles, Ceramics, Metalwork*, Cranbrook Academy of Art, Bloomfield Hills, Michigan
1951	*Good Design, 1951*, Merchandise Mart, Chicago, organized by the Museum of Modern Art, New York
1952	*From Rock to Beauty*, America House, New York, mounted by the American Craftsmen's Educational Council
1952	*Arts and Crafts, Painting and Sculpture*, Los Angeles County Fair, Pomona: first prize for leathercraft

1953	*Young Americans 1953*, America House, New York, organized by the American Craftsmen's Educational Council: third prize for "reversible" pin
1953	*American Craftsmen 1953*, University of Illinois, Urbana; circulated by the Smithsonian Institution Traveling Exhibition Service
1953	*Arts and Crafts, Painting and Sculpture*, Los Angeles County Fair, Pomona: prize for pliable materials

1953	*Fiber – Clay – Metal – 1953*, Second Annual National Craft Competition, St. Paul Gallery & School of Art, Minneapolis
1953	*84 Contemporary Jewelers: American Jewelry Designers and Their Work*, Walker Art Center, Minneapolis
1953	*An Exhibition of Contemporary Silverwork and Ceramic Sculpture at the Wisconsin Memorial Union Gallery*, Department of Art Education, University of Wisconsin
1953	*Designer Craftsmen U.S.A. 1953*, initiated by the American Craftsmen's Educational Council; Brooklyn Museum, the Art Institute of Chicago and the San Francisco Museum of Art; later circulated under the American Federation of Arts
1954	*Good Design*, *1954*, Merchandise Mart, Chicago, organized by the Museum of Modern Art, New York
1955	*American Craftsmen 1955*, University of Illinois, Urbana; circulated by the Smithsonian Institution Traveling Exhibition Service
1955	Marries artist and business partner William O. Steinmetz

1955	Establishes Cooke & Steinmetz consulting firm while continuing to work on jewelry
1956	Profiled in Don Wallance's *Shaping America's Products* (New York: Reinhold Publishing Corporation, 1956, 162–63)
1957	*American Craftsmen 1957*, University of Illinois, Urbana; circulated by the Smithsonian Institution Traveling Exhibition Service
1963	*First Invitational Crafts Exhibition*, Art Department and Associated Students of Long Beach State College
1963	*Craftsmen of the Northeastern States*, organized by the Museum of Contemporary Crafts of the American Craftsmen's Council, held at the Worcester Art Museum
1965	The Store Ltd opens in The Village of Cross Keys, Baltimore
1976	"Necksculpture" offered by the gift shop at the Museum of Modern Art, New York
1979	De Beers "Diamonds Today" award
1981	De Beers "Diamonds Today" award

1985	Jewelry collaboration with Kirk-Stieff, Baltimore silversmiths
1985	*Structure and Ornament: American Modernist Jewelry 1940–1960*, FIFTY-50, New York
1987	Receives Alumni Award, Maryland Institute College of Art
1995	*Design–Jewelry–Betty Cooke*, Meyerhoff Gallery, Maryland Institute College of Art, Baltimore
1996	*Messengers of Modernism: American Studio Jewelry 1940–1960*, Montreal Museum of Decorative Arts, circulated to eight other venues in North America and Europe

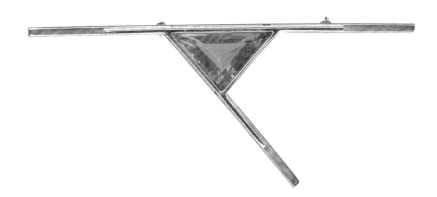

1996	Elected to College of Fellows, American Craft Council
2002	*Women Designers in the USA, 1900–2000: Diversity and Difference*, Bard Graduate Center for Studies in the Decorative Arts, New York
2004	Interviewed by Jan Yager for the Smithsonian Archives of American Art
2010	*Jewelry by Artists in the Studio, 1940–2000*, Museum of Fine Arts, Boston
2011	*Crafting Modernism: Midcentury American Art and Design*, Museum of Arts and Design, New York, and the Memorial Art Gallery of the University of Rochester
2014	*Dedicated* (with William O. Steinmetz), Maryland Institute College of Art, Baltimore, June 6–22
2014	Awarded Honorary Degree of Humane Letters by the Maryland Institute College of Art
2014	*Betty Cooke: Selections*, Goya Gallery, Baltimore, April 17–June 5
2016	Death of William O. Steinmetz
2017	*Jewelry of Ideas: The Susan Grant Lewin Collection*, Cooper Hewitt, Smithsonian Design Museum, New York, November 10, 2017–May 28, 2018
2019	*Free Form: 20th-Century Studio Craft*, Baltimore Museum of Art, December 18, 2019–June 7, 2020

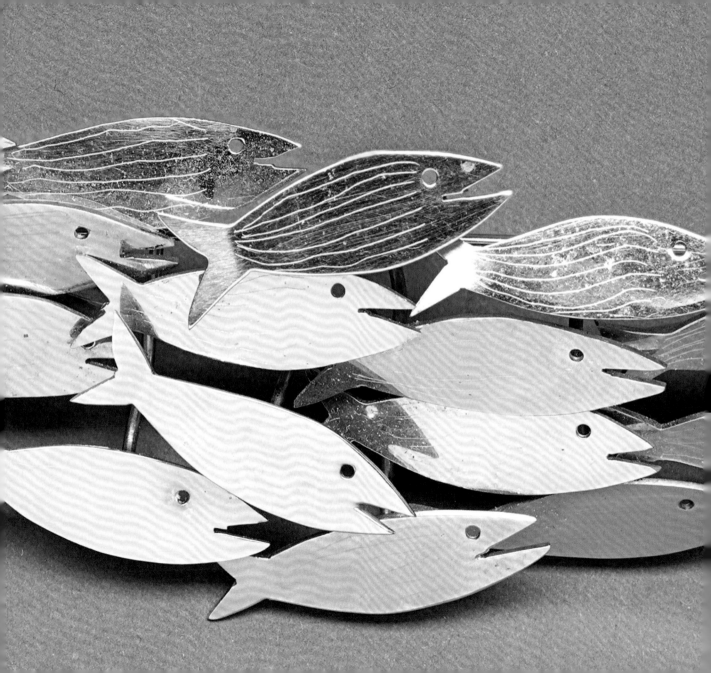

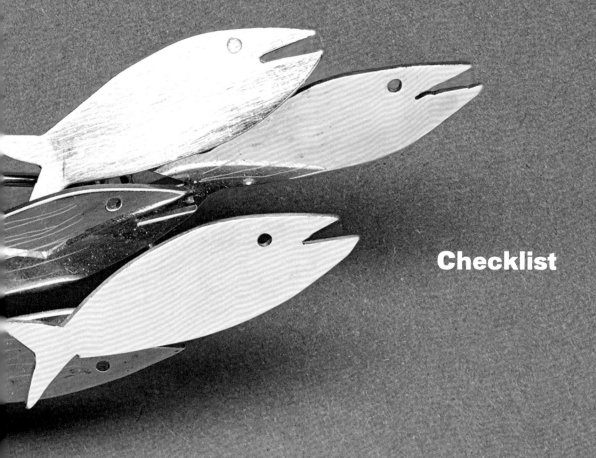

Checklist

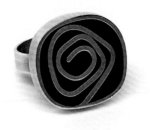

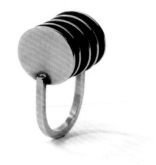

1 **Pin, 1947–55**
Silver, ebony
1 × 3 ¼ in. (2.54 × 8.26 cm)
Collection of Amy Davis Gold

2 **Ring, ca. 1947–60**
Silver
¹⁵⁄₁₆ × ¾ × ⅞ in. (2.38 × 1.91 × 2.22 cm)
Collection of Vivian Fliegel Olsavicky and Gary Olsavicky

3 **Ring, ca. 1947–60**
Silver
1 ¼ × ¾ × ¾ in. (3.18 × 1.91 × 1.91 cm)
Collection of Vivian Fliegel Olsavicky and Gary Olsavicky

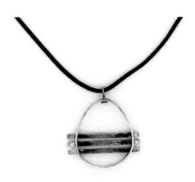

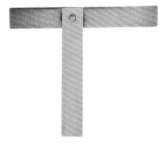

4 **Neckpiece, ca. 1948**
Silver, brass
5 ½ × 5 ½ × ⁵⁄₁₆ in. (13.9 × 14 × 0.8 cm)
The Susan Grant Lewin Collection, Cooper Hewitt,
Smithsonian Design Museum, 2017-2-1

5 **Pendant necklace, ca. 1949**
Silver, enamel, leather cord
Pendant: 2 × 2 in. (5.1 × 5.1 cm)
Baltimore Museum of Art, Bequest of Saidie A. May, 1951,
1952.145

6 **Pin, ca. 1949**
Silver, brass
3 × 3 in. (7.62 × 7.62 cm)
Collection of Munir Meghji

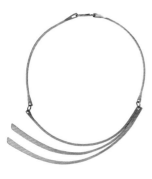

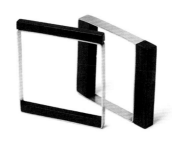

7 Neckpiece, ca. 1950–60
Silver
6 × 4 ¾ × ⅛ in. (15.24 × 12.07 × 0.32 cm)
Collection of the artist

8 Bracelets, ca. 1950
Silver, ebony
2 ¹³⁄₁₆ × 2 ½ × ³⁄₁₆ in. (7.14 × 6.35 × 0.48 cm);
2 ¹³⁄₁₆ × 2 ⁹⁄₁₆ × ³⁄₁₆ in. (7.14 × 6.51 × 0.48 cm)
Collection of the artist

9 Pin, ca. 1950
Silver, Plexiglas
1 ¼ × 2 in. (3.2 × 5.1 cm)

Baltimore Museum of Art, Gift of Brenda Richardson,
Baltimore, in Memory of Gertrude Rosenthal, beloved Friend
and Mentor, 1998.47

10 Pin, ca. 1950
Silver, pebble
⅞ × 3 ⅝ × ½ in. (2.22 × 9.21 × 0.64 cm)
Collection of the artist

11 Pin, ca. 1950–55
Silver, ebony
2 ⅞ × 2 ⅞ × ¼ in. (7.3 × 7.3 × 0.64 cm)
Collection of the artist

12 Neckpiece, ca. 1950–60
Silver
11 ½ × 11 in. (29.21 × 27.94 cm)
Collection of Renata Ramsburg

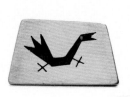
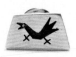
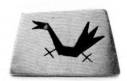
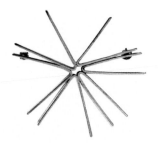

13 **Cufflinks and tie tack, 1950–65**
Silver, enamel
Cufflinks: ⅝ × 1 ⅛ × ½ in. (1.58 x 2.86 x 1.27 cm); tie tack: ⅜ × ½ × ⅝ in. (0.95 x 1.27 x 1.59 cm)
Collection of Munir Meghji

14 **Pin, 1950–65**
Silver
Diam. 2 ¾; d. ¼ in. (6.99; 0.64 cm)
Collection of the artist

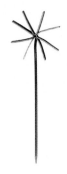
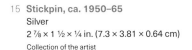

15 **Stickpin, ca. 1950–65**
Silver
2 ⅞ × 1 ½ × ¼ in. (7.3 × 3.81 × 0.64 cm)
Collection of the artist

16 **Pin, ca. 1950–65**
Silver, rutilated quartz
⅞ × 3 in. (2.22 × 7.62 cm)
Collection of Vivian Fliegel Olsavicky and Gary Olsavicky

17 **Pin, 1950–65**
Silver, ebony
1 ½ × 3 ⅓ in. (3.81 × 8.47 cm)
Collection of Amy Davis Gold

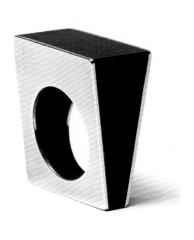

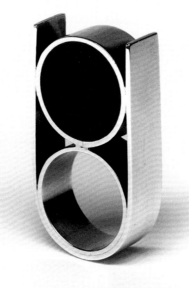

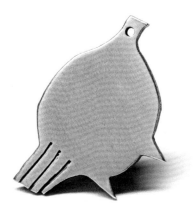

18 **Ring, ca. 1950–65**
Silver, ebony
1 1/8 × 15/16 × 1/2 in. (2.86 × 2.38 × 1.27 cm)
Collection of the artist

19 **Ring, ca. 1950–65**
Silver, onyx
2 1/8 × 7/8 × 3/4 in. (5.4 × 2.22 × 1.91 cm)
Collection of the artist

20 **Pin, ca. 1950–65**
Silver
3/8 × 7/8 × 1/8 in. (.95 × 2.22 × .32 cm)
Collection of the artist

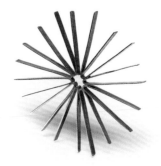

21 **Stickpin, ca. 1950–65**
Silver
2 ³⁄₁₆ × 1 ⅛ × ⅛ in. (5.56 × 2.86 × 0.32 cm)
Collection of the artist

22 **Pin, ca. 1950–70**
Silver
1 ⅛ × ¹⁄₁₆ × ⅛ in. (2.86 × 0.14 × 0.32 cm)
Collection of the artist

23 **Pin, ca. 1950–70**
Silver
Diam. 2 ⅞; d. ¼ in. (7.3; 0.64 cm)
Collection of the artist

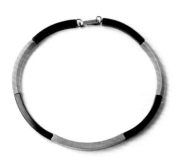

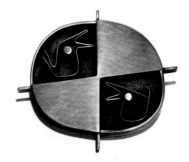

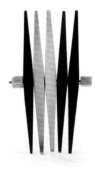

24 **Necklace, ca. 1951**
Silver, plastic
4 ½ × 5 × ½ in. (11.43 × 12.7 × 1.27 cm)
Collection of the artist

25 **Pin, 1951**
Silver
2 ¹⁄₁₆ × 2 ⁵⁄₁₆ in. (5.3 × 5.9 cm)
Collection Cranbrook Art Museum, Bloomfield Hills,
Michigan, 1951.150

26 **Pin, ca. 1951–53**
Silver, Plexiglas
3 ¼ × 1 ⅝ in. (8.26 × 4.13 cm)
Collection of Howard Auerbach and Ken Maffia

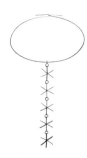

27 **Pendant neckpiece, 1953**
Silver
11 × 5 in. (27.94 × 12.7 cm)
Collection of the artist

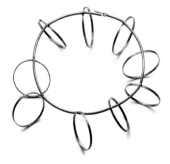

28 **Neckpiece, ca. 1955**
Silver
H. 2; diam. 9 in. (5.08; 22.86 cm)
Museum of Fine Arts, Boston, The Daphne Farago Collection, 2006.103

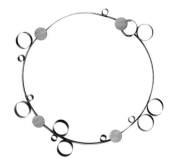

29 **Neckpiece, ca. 1955**
Silver
Diam. 6 ½; d. ¼ in. (16.51; 0.64 cm)
Collection of the artist

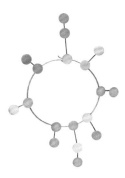

30 **Neckpiece, ca. 1955**
Silver
Diam. 8 ¼; d. ⅝ in. (20.96; 1.59 cm)
Collection of the artist

31 **Pin, ca. 1955–60**
Silver, ebony
2 × 2 ¼ in. (5.08 × 5.72 cm)
Collection of Munir Meghji

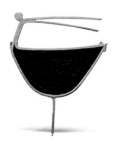

32 **Pin, ca. 1955–65**
Silver, ebony
1 ½ × 1 ⅜ × ¼ in. (3.81 × 3.49 × 0.64 cm)
Collection of the artist

Reflection
Nancy Rome

My mother, Frances Rome, met Betty when she and Bill were down on Tyson Street in the '50s, when Mom was one of those starting the Sales and Rental Gallery at the Baltimore Museum of Art. They remained good friends until my mother died a couple of years ago. No one felt they were truly a part of our family unless they'd been given "a Betty" for birthdays or anniversaries—it was the only thing any of us ever really asked for. I think my first Betty was a tiny circular pin with an enamel owl in the middle. . . I couldn't have been more than ten at the time.

Betty was always our style guru and still is—the essence of grace and elegance. The Store Ltd has always been my favorite place to find beautiful presents in Baltimore. She is one of our great American modernists, my lifelong friend, and a model of artistic integrity, creativity, inventiveness, kindness, and extraordinary humility.

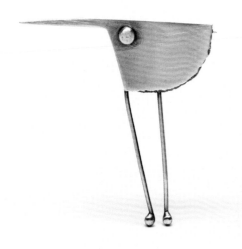

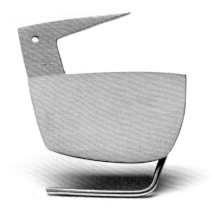

33 **Pin, ca. 1955–65**
Silver
1 ½ × 1 ⁷⁄₁₆ in. (3.81 × 3.65 cm)
Collection of the artist

34 **Pin, ca. 1955–65**
Silver, brass
1 ³⁄₁₆ × 1 ¹⁄₁₆ in. (3.02 × 2.7 cm)
Collection of the artist

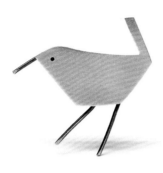

35 **Pin, ca. 1955–65**
Silver
1 ½ × 1 ½ × ⅛ in. (3.81 × 3.81 × 0.32 cm)
Collection of the artist

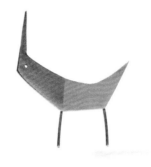

36 **Pin, ca. 1955–65**
Brass
1 ¾ × 1 ½ × ⅛ in. (4.45 × 3.81 × 0.32 cm)
Collection of the artist

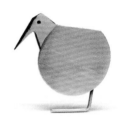

37 **Pin, ca. 1955–65**
Silver, brass
1 ¼ × 1 ⅕ × ⅛ in. (3.18 × 3.05 × 0.32 cm)
Collection of the artist

38 **Pin, ca. 1955–65**
Silver, brass
1 ⅛ × 1 ¼ × ⅛ in. (2.86 × 3.18 × 0.32 cm)
Collection of the artist

39 **Pin, ca. 1955–65**
Silver, enamel
Diam. 1 ¼; d. ¼ in. (3.18; 0.64 cm)
Collection of the artist

40 **Pin, ca. 1955–65**
Silver, Plexiglas
1 ¼ × 2 ¾ × ⅛ in. (3.18 × 6.99 × 0.32 cm)
Collection of the artist

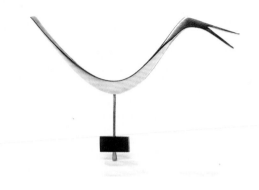

41 **Pin, ca. 1955–65**
Silver, ebony
2 ½ × 3 ⅝ × ¼ in. (6.35 × 9.21 × 0.64 cm)
Collection of the artist

42 **Pin, ca. 1955–65**
Silver, brass
¹³⁄₁₆ × 1 ⅝ × ⅛ in. (2.06 × 4.13 × 0.32 cm)
Collection of the artist

43 **Pin, ca. 1955–65**
Silver, brass
1 ½ × 1 ⅞ × ³⁄₁₆ in. (3.81 × 4.76 × 0.48 cm)
Collection of the artist

44 **Pin, ca. 1955–65**
Silver, brass
¹³⁄₁₆ × 1 ⅝ × ³⁄₁₆ in. (2.06 × 4.13 × 0.48 cm)
Collection of the artist

45 **Pin, ca. 1955–65**
Silver
1 ⅝ × 1 ⅜ × ¼ in. (4.13 × 3.5 × 0.64 cm)
Collection of the artist

46 **Pin, ca. 1955–65**
Silver
1 1/16 × 7/8 × 1/8 in. (2.7 × 2.22 × 0.32 cm)
Collection of the artist

47 **Pin, ca. 1955–65**
Silver, copper, enamel
Diam. 1 1/4; d. 1/4 in. (3.18; 0.64 cm)
Collection of the artist

48 **Pin, ca. 1955–65**
Silver, copper, enamel
Diam. 1 1/4; d. 1/4 in. (3.18; 0.64 cm)
Collection of the artist

49 **Earrings, ca. 1955–65**
Silver, copper, enamel
Diam. 3/4; d. 1/4 in. (1.91; 0.64 cm)
Collection of the artist

50 **Pin, ca. 1955–65**
Silver, enamel
Diam. 1 1/4; d. 1/4 in. (3.18; 0.64 cm)
Collection of the artist

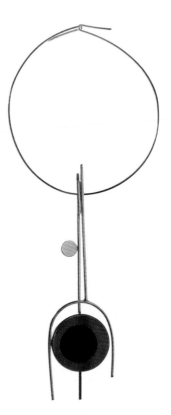

51 **Pin, ca. 1955–65**
Silver, resin
2 × 3 × ¼ in. (5.08 × 7.62 × 0.64 cm)
Private collection

52 **Neckpiece with pendants, ca. 1955–65**
Silver, resin
12 ½ × 5 in. (31.75 × 12.7 cm)
Collection of Vivian Fliegel Olsavicky and Gary Olsavicky

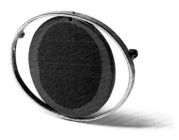

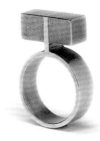

53 **Pin, ca. 1955–65**
Silver, resin
1 ⅝ × 2 ⅛ × ¼ in. (4.13 × 5.4 × 0.64 cm)
Collection of the artist

54 **Pin, ca. 1955–65**
Silver, resin
2 × 2 ½ × ¼ in. (5.08 × 6.35 × 1.27 cm)
Collection of Vivian Fliegel Olsavicky and Gary Olsavicky

55 **Ring, ca. 1955–70**
Silver, brass
1 ⅞ × ⅞ × ⁵⁄₁₆ in. (4.76 × 2.22 × 0.79 cm)
Collection of the artist

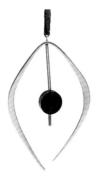

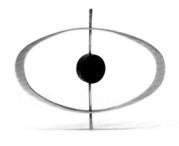

56 **Pendant necklace, ca. 1955–65**
Silver, ebony, leather
Pendant: 2 ¼ × 1 ½ in. (5.72 × 3.81 cm)
Collection of Sandra Levi Gerstung

57 **Pin, ca. 1955–75**
Silver, ebony
⅝ × 4 ⅛ × ¼ in. (1.59 × 10.48 × 0.64 cm)
Collection of the artist

58 **Pin, ca. 1955–65**
Silver, ebony
2 ¹⁄₁₆ × 2 1¹⁄₁₆ × ⅛ in. (6.67 × 6.82 × 0.32 cm)
Collection of the artist

Reflection
Laurin (Monk) B. Askew Jr.

Fellow of the American Institute of Architects

Betty and Bill have done more to influence good design (in the Baltimore community and region) than anyone I know. Betty is always about good design, believing in what she does, and bringing it to all aspects of her life—creating her own unique 'brand' in the process.

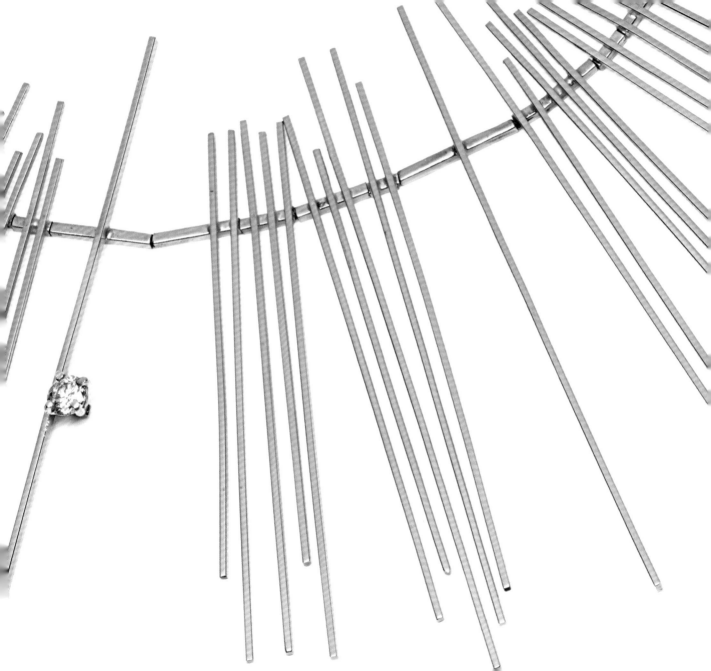

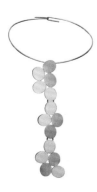

59 Pendant neckpiece, 1955–75
Silver
10 ¼ × 4 ¼ in. (26.04 × 10.8 cm)
Collection of the artist

60 Suite: pins, ca. 1955–2020
Silver
Dimensions variable
Collection of the artist

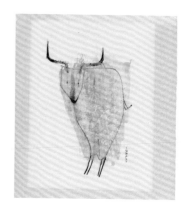

61 *Bull*, before 1957
Pen and black ink, opaque watercolor,
graphite
Sheet: 9 ⅝ × 7 ⁵⁄₁₆ in. (24.5 × 18.5 cm)
Baltimore Museum of Art, Bequest of J. Blankfard
Martenet, 1957.216.8

62 *Abstraction with Tree and Moon*,
before 1957
Collage of colored papers
Sheet: 10 ¾ × 15 ¹⁵⁄₁₆ in. (27.31 × 40.48 cm)
Baltimore Museum of Art, Bequest of J. Blankfard Martenet,
1957.216.14.11

63 *Three Porcupines*, before 1957
Pen and black ink with watercolor
Sheet: 6 ⅞ × 8 ⅛ in. (17.4 × 20.6 cm)
Baltimore Museum of Art, Bequest of J. Blankfard
Martenet, 1957.216.21

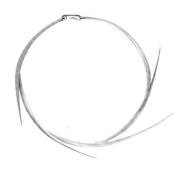

64 Neckpiece, ca. 1960–70
Silver
6 × 5 × ⅛ in. (15.24 × 12.7 × 0.32 cm)
Collection of the artist

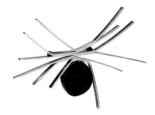

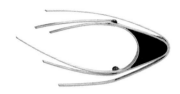

65 **Pin, ca. 1960–70**
Silver, ebony
2 × 3 ¼ × ¼ in. (5.08 × 8.26 × 0.64 cm)
Collection of the artist

66 **Pin, ca. 1960–70**
Silver, ebony
2 × 3 9⁄16 × ¼ in. (5.08 × 9.05 × 0.64 cm)
Collection of the artist

67 **Pin, ca. 1960–70**
Silver, Plexiglas
2 ¼ × 1 ¼ in. (5.72 × 3.18 cm)
Collection of Sandra Levi Gerstung

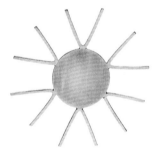

68 **Pin, ca. 1960–75**
Silver, brass
Diam. 1 15⁄16; d. ¼ in. (4.92; 0.64 cm)
Collection of the artist

69 **Pin, ca. 1960–75**
Silver, brass
Diam. 2 3⁄8; d. 1⁄8 in. (6.03; 0.32 cm)
Collection of the artist

70 **Pin, ca. 1960–70**
Silver, brass
1 ½ × 1 ½ × 1⁄8 in. (3.81 × 3.81 × 0.32 cm)
Collection of the artist

71 **Pin, ca. 1960–70**
Silver, brass
1 ⅞ × 2 ¼ × ⅛ in. (4.76 × 5.72 × 0.32 cm)
Collection of the artist

72 **Pin, ca. 1960–70**
Silver, ebony
1 ⅝ × 2 ½ × ⅛ in. (4.13 × 6.35 × 0.32 cm)
Collection of the artist

73 **Pin, ca. 1960–75**
Silver, brass
4 ⅛ × 2 × ⅛ in. (10.47 × 5.08 × 0.13 cm)
Collection of the artist

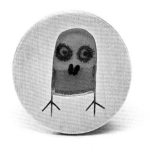

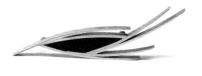

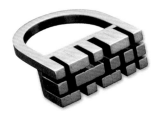

74 **Pin/pendant, ca. 1966**
Silver, enamel
Diam. 1; d. ¼ in. (2.54; .64 cm)
Collection of Nancy Rome

75 **Pin, ca. 1965–75**
Silver, ebony
1 × 3 ¾ × ⅛ in. (2.54 × 9.53 × 0.32 cm)
Collection of the artist

76 **Ring, 1965–70**
Silver, gold
1 ¼ × 1 × ½ in. (3.2 × 2.5 × 1.3 cm)
Museum of Fine Arts, Boston, The Daphne Farago
Collection, 2006.104

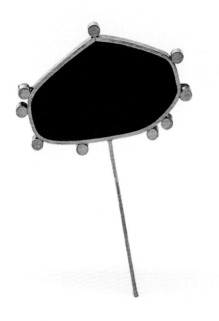

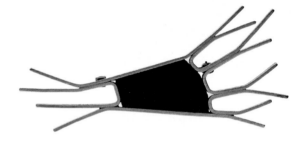

77 **Pin, ca. 1965–75**
Silver, ebony
3 × 1 ⅞ × ¼ in. (7.62 × 4.76 × 0.64 cm)
Collection of the artist

78 **Pin, ca. 1965–75**
Silver, ebony
1 ¼ × 2 ½ × ¼ in. (3.18 × 6.35 × 0.64 cm)
Collection of the artist

79 **Ring, ca. 1965**
Gold, quartz
1 ⅞ × 1 ¼ × ¹³⁄₁₆ in. (4.76 × 3.18 × 2.06 cm)
Collection of the artist

80 **Ring, ca. 1970–75**
Silver
1 ¼ × ¾ × 1 in. (3.18 × 1.91 × 2.54 cm)
Collection of Sandra Levi Gerstung

81 **Pin, ca. 1970–80**
Gold, chalcedony
1 ⁵⁄₁₆ × 3 ⅛ × ⅛ in. (3.33 × 7.94 × 0.32 cm)
Collection of the artist

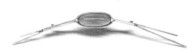

82 **Pin, ca. 1970–80**
Gold, chalcedony
1 ½ × 5 ½ × ⅛ in. (3.81 × 13.97 × 0.32 cm)
Collection of the artist

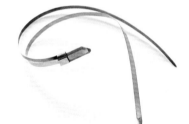

83 **Neckpiece, ca. 1970–80**
Gold, quartz
10 × 7 × 2 ½ in. (25.4 × 17.78 × 6.35 cm)
Collection of the artist

84 **Bracelet, ca. 1970–80**
Silver, bone
3 × 3 × 1 in. (7.62 × 7.62 × 2.54 cm)
Collection of the artist

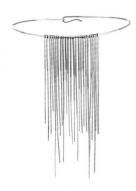

85 Neckpiece, ca. 1970–80
Gold
10 ¼ × 7 ½ in. (26.04 × 19.05 cm)
Collection of Renata Ramsburg

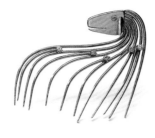

86 **Pin, 1975**
Gold, diamond
1 ⅞ × 2 ¼ in. (4.76 × 5.72 cm)
Private collection

87 **Pin/pendant, 1975**
Silver, gold
1 × 1 in. (2.54 × 2.54 cm)
Collection of Patty Rouse and her family

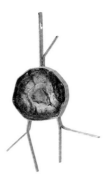

88 **Pendant, 1975**
Gold, watermelon tourmaline
4 ¼ × 3 in. (10.8 × 7.62 cm)
Private collection

89 **Neckpiece, ca. 1975**
Gold
1 ½ x 5 x 4 ½ in. (3.82 x 13.34 x 11.43 cm)
Collection of the artist

90 **Two-part ring, ca. 1975–95**
Gold, pearl
H. ½; diam. 1 in. (1.27; 2.54 cm)
Collection of Sandra Levi Gerstung

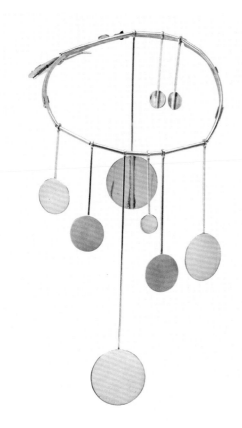

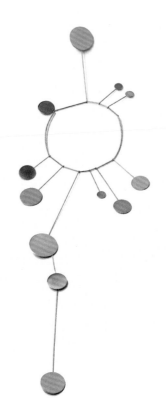

91 **Neckslculpture, 1976**
Silver
9 ¼ × 17 × 1 ⅛ in. (23.5 × 43.2 × 2.9 cm)
Baltimore Museum of Art, Gift of Barbara Katz, Baltimore, 2019.7

92 **Neckslculpture, ca. 1976**
Gold
24 × 9 in. (60.96 × 22.86 cm)
Private collection

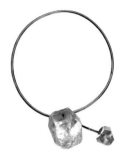

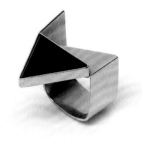

93 **Bicentennial necklace, 1976**
Gold, silver
13 × 4 in. (33.02 × 10.16 cm)
Private collection

94 **Neckpiece, 1978**
Silver, quartz
7 ½ × 5 ¾ in. (19.05 × 14.61 cm)
Collection of Amy Davis Gold

95 **Ring, ca. 1980**
Gold, onyx
1 × ⅞ × ⅞ in. (2.54 × 2.22 × 2.22 cm)
Collection of the artist

96 **Neckpiece, ca. 1980–85**
Gold, ebony
5 ½ × 5 ½ in. (13.97 × 13.97 cm)
Collection of Christine Bangs

97 **Necklace, ca. 1980–90**
Silver
12 × 6 in. (30.48 × 15.24 cm)
Collection of the artist

98 **Suite: bracelet and two-part ring,
ca. 1980**
Gold, lapis lazuli
Bracelet: ⅔ × 2 ¾ × 2 ⅓ in. (1.7 × 7 × 6 cm); ring:
h. 1 1/16; diam. ⅔ in. (2.7; 1.7 cm)
Private collection

Reflection
Nan-Kirsten Forte

And of course: love, love, love, and more love to the force of life, creativity, art, youth, and inspiration that is the unparalleled Betty Cooke.

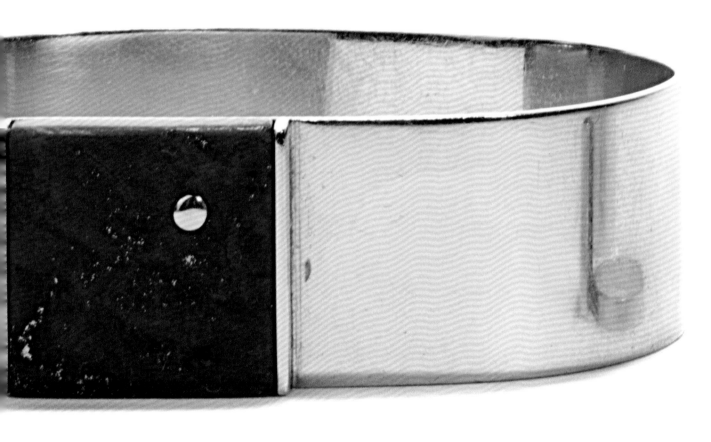

99 **Neckpiece, ca. 1980–90**
Gold
½ × 5 ½ × 5 ½ in. (1.27 × 11.43 × 11.43 cm)
Collection of Sandra Levi Gerstung

100 **Bracelet, 1981**
Gold, diamond, pebble
2 ½ × 2 ⅛ × ¾ in. (6.35 × 5.4 × 1.91 cm)
Collection of the artist

101 **Neckpiece, ca. 1981**
Gold, pebble
6 × 5 ½ × ¾ in. (15.24 × 13.97 × 1.91 cm)
Collection of the artist

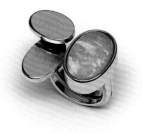

102 **Pin, 1985**
Gold, moonstone, chalcedony
2 ¼ × 1 ¼ × ⅜ in. (5.72 × 3.18 × 0.95 cm)
Collection of Patty Rouse and her family

103 **Two-part ring, ca. 1985; designed
ca. 1976**
Gold, diamond
1 × 1 ¼ × 1 ¼ in. (2.54 × 3.18 × 3.18 cm)
Collection of Vivian Fliegel Olsavicky and Gary Olsavicky

104 **Ring, 1985**
Gold, opal
1 × 1 × ⅞ in. (2.54 × 2.54 × 2.22 cm)
Private collection

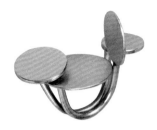

105 **Ring, ca. 1985**
Gold, opal
1 ¼ × 1 ¼ × 1 ¼ in. (3.18 × 3.18 × 3.18 cm)
Collection of the artist

106 **Ring, ca. 1985**
Silver, gold
1 ⁹⁄₁₆ × 2 ¹⁄₁₆ × 1 ³⁄₁₆ in. (3.97 × 5.24 × 3.02 cm)
The Susan Grant Lewin Collection, Cooper Hewitt,
Smithsonian Design Museum, 2016-34-16

107 **Ring, ca. 1985**
Gold
1 × 1 ¾ in. (2.54 × 4.45 cm)
Private collection

108 **Pin, ca. 1985**
Gold, diamond
Diam. 1 ⅞ in. (4.76 cm)
Private collection

109 **Ring, ca. 1985**
Gold
1 ¼ × 1 ⅕ × 1 ¼ in. (3.18 × 3.05 × 3.18 cm)
Collection of the artist

110 **Pin, 1986**
Gold, emerald
2 ¾ × 2 ½ × ⅛ in. (6.99 × 6.35 × 0.32 cm)
Collection of Patty Rouse and her family

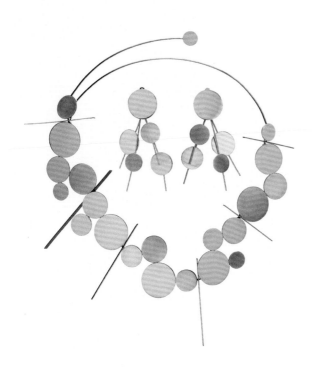

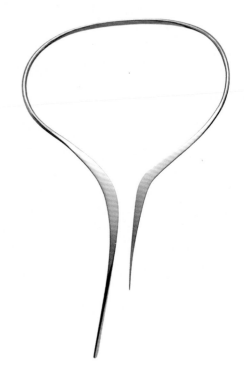

111 **Suite: neckpiece and earrings, 1988**
Gold
Neckpiece: 8 × 8 in. (20.32 × 20.32 cm);
earrings: 2 ½ × 2 in. (6.35 × 5.08 cm)
Private collection

112 **Neckpiece, 1988**
Gold
9 ⅛ × 5 ¼ × 1 ⅝ in.
(23.18 × 13.22 × 4.18 cm)
Collection of Martha Head

113 **Neckpiece, 1989; designed ca. 1959**
Gold
10 ½ × 6 ⅞ × ½ in. (26.67 × 17.46 × 1.27 cm)
Collection of Martha Head

114 **Neckpiece with pendant, 1990**
Silver
L. 22 in. (55.88 cm)
Collection of Amy Davis Gold

115 **Pin, 1990**
Silver
1 × 1 × ¼ in. (2.54 × 2.54 × 0.64 cm)
Collection of Betty Davis

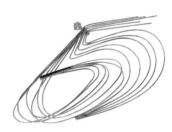

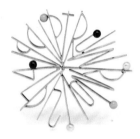

116 **Pin, 1991**
Gold, emerald
2 ½ × 5 × ⅛ in. (6.35 × 12.7 × 0.32 cm)
Collection of Patty Rouse and her family

117 **Necklace, 1992**
Gold, lapis lazuli, turquoise
11 in. (27.94 cm); pendant: 2 in. (5.08 cm)
Collection of Patty Rouse and her family

118 **Pin, 1992**
Gold, turquoise, pearl
Diam. 3 in. (7.62 cm)
Collection of Patty Rouse and her family

Reflection
David and JoAnn Hayden

student. mentor. icon. lifelong friend. for over half of a century betty's minimalist approach to design and life has been the inspiration for the lives we live. . . we love you!

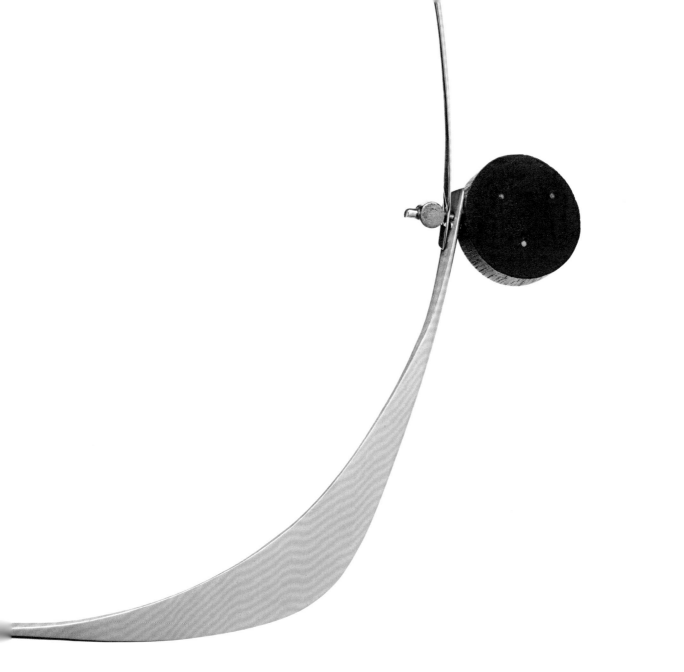

119 **Necklace, 1993**
Gold, onyx, leather
17 × 1 ⅞ in. (43.18 × 1.87 cm)
Private collection

120 **Pin, 1993**
Gold
2 ¼ × 4 ½ in. (5.72 × 11.43 cm)
Collection of Patty Rouse and her family

121 **Neckpiece, 1993**
Gold, ebony
9 × 6 in. (22.86 × 15.24 cm)
Private collection

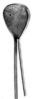

122 **Necklace, ca. 1993**
Gold, silver
11 × 5 in. (27.94 × 12.7 cm)
Private collection

123 **Neckpiece, 1994**
Gold, tourmaline
7 ½ × 6 in. (19.05 × 15.24 cm)
Collection of Patty Rouse and her family

124 **Earrings, ca. 1995**
Gold, opal
1 ¾ x ½ in. (4.45 x 1.27 cm)
Collection of Lynn Harris-McCorkle, MD

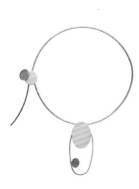

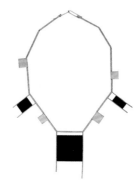

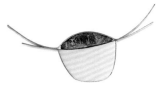

125 **Neckpiece with pendant, ca. 1995**
Gold, silver
Neckpiece: 6 × 5 ½ in. (15.24 × 13.97 cm);
pendant: 3 × 1 ½ in. (7.62 × 3.81 cm)
Collection of Lois Blum Feinblatt

126 **Necklace, 1997**
Gold, silver, onyx
10 × 6 in. (25.4 × 15.24 cm)
Private collection

127 **Pin, 1998**
Gold, opal
1 ⅛ × 2 ¾ in. (2.86 × 6.99 cm)
Private collection

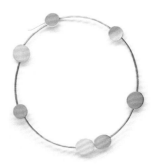

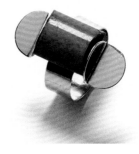

128 **Necklace, 1998**
Gold
22 × 4 in. (55.88 × 10.16 cm)
Collection of Jonna G. Lazarus

129 **Necklace, 2000**
Gold
Diam. 5 ¾ in. (13.97 cm)
Collection of Amy Davis Gold

130 **Ring, 2001**
Gold, lapis lazuli
H. 1 ¼; diam. ¾ in. (3.18; 1.91 cm)
Collection of Dasha Snyder

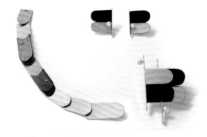

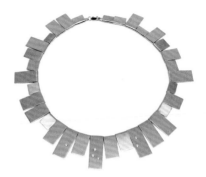

131 **Suite: bracelet, brooch, earrings, 2001**
Gold, ebony
Bracelet: ½ × 7 ¼ × ⅛ in. (1.27 × 18.42 × 0.32 cm);
brooch: 2 ¾ × 1 ½ × ⅛ in. (6.99 × 3.81 × 0.32 cm);
earrings: 1 ¼ × ⅞ × ⅛ in. (3.18 × 2.22 × 0.32 cm)
Private collection

132 **Necklace, 2004**
Gold, diamond
7 × 6 ¼ in. (17.78 × 15.88 cm)
Private collection

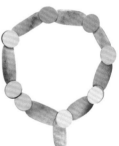

133 **Necklace, 2006**
Gold, ebony
8 × 11 in. (20 × 27.94 cm)
Private collection

134 **Earrings, 2007**
Gold, onyx
3 ¼ × 1 ¼ in. (8.26 × 3.18 cm)
Private collection

135 **Necklace, 2008**
Gold
7 ½ × 6 in. (19.05 × 15.24 cm)
Private collection

136 **Pin, 2009**
Gold
1 ¼ × 4 ½ in. (3.17 × 11.43 cm)
Private collection

137 **Pin, 2009**
Gold, silver, ebony
4 × 4 ⅓ in. (10.16 × 10.99 cm)
Private collection

138 **Pendant, 2009**
Silver
5 ½ × 4 in. (13.97 × 10.16 cm)
Private collection

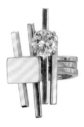

139 **Three part ring, 2009**
Gold, diamond
Assembled dimensions, overall:
¾ × ¾ × ¾ in. (1.91 × 1.91 × 1.91 cm)
Private collection

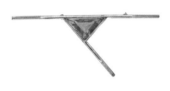

140 **Pin, 2009**
Gold, opal
3 ⅛ × 2 ½ in. (7.93 × 6.35 cm)
Private collection

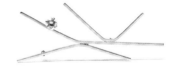

141 **Pin, ca. 2010**
Gold, diamond
2 × 3 in. (5.08 × 7.62 cm)
Collection of Barbara Bozzuto

Reflection
Betty Cooke

I think in terms of jewelry, but jewelry is also sculpture that can be done on a large scale.

(Gabrielle Wise, "Designer Finds a Pot of Gold and Pebbles," *Baltimore Sun*, July 24, 1979)

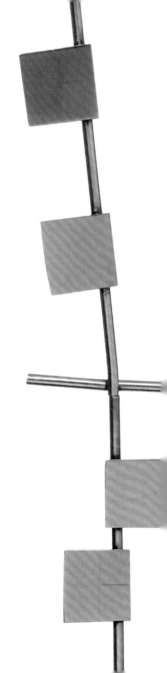

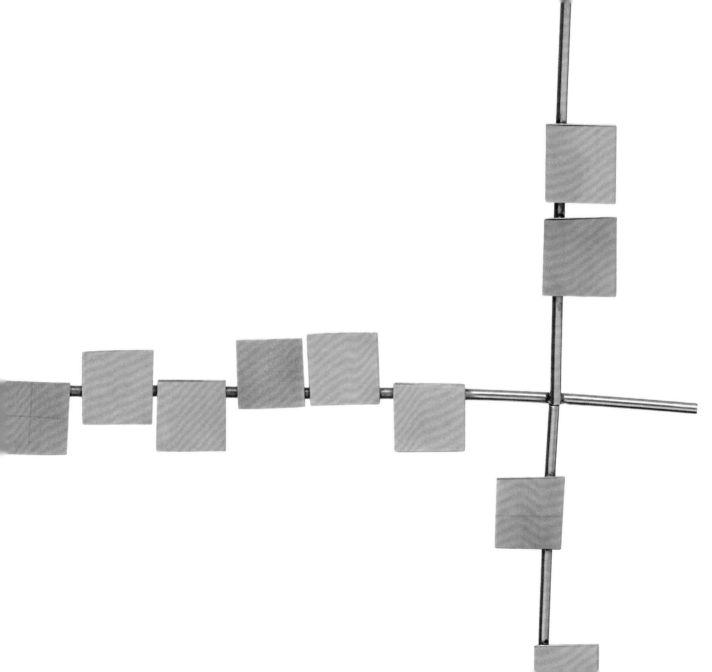

142 **Pin, ca. 2011**
Gold, opal
2 ½ × 2 ½ in. (6.35 × 6.35 cm)
Private collection

143 **Suite: necklace and earrings, ca. 2012**
Gold, pearl
Necklace: 7 ½ × 6 ½ in. (19.05 × 16.51 cm);
earrings: 3 ¾ in. (9.53 cm)
Collection of Berthe Hanover Ford

144 **Neckpiece with pendant, ca. 2012**
Gold, jade
9 × 5 in. (22.86 × 12.7 cm)
Private collection

145 **Necklace, 2012**
Gold
7 ½ × 5 ½ in. (19.05 × 13.97 cm)
Susan Grant Lewin Collection

146 **Necklace, 2012**
Gold, lapis lazuli
12 × 9 ½ in. (30.48 × 24.13 cm)
Private collection

147 **Neckpiece, ca. 2012**
Silver
9 ½ × 5 ½ in. (24.13 × 13.97 cm)
Private collection

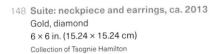

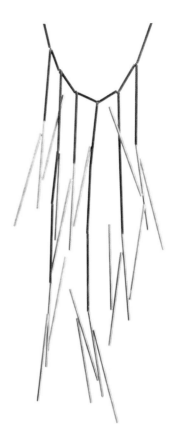

148 **Suite: neckpiece and earrings, ca. 2013**
Gold, diamond
6 × 6 in. (15.24 × 15.24 cm)
Collection of Tsognie Hamilton

149 Necklace, 2014
Gold, silver
15 × 6 in. (38.1 × 15.24 cm)
Private collection

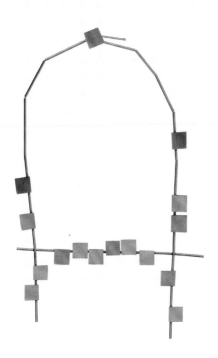

150 **Necklace, 2014**
Gold
9 × 6 in. (22.86 × 15.24 cm)
Collection of Jonna G. Lazarus

151 **Necklace, 2015**
Gold, diamond
10 × 7 ¾ in. (25.4 × 19.69 cm)
Private collection

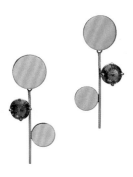

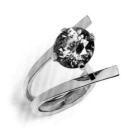

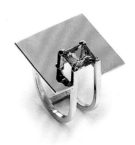

152–154 **Suite: earrings, pin, ring, 2015**
Gold, peridot
Earrings: 2 × 1 ¾ in. (5.08 × 4.45 cm);
pin: ¹³⁄₁₆ × 1 in. (2.06 × 2.54 cm);
ring: 1 ⅜ × ⅞ in. (3.49 × 2.22 cm)
Private collection

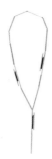

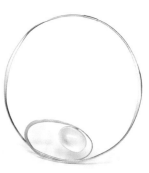

155 **Necklace, 2017**
Gold, ebony
18 × 4 in. (45.72 × 10.16 cm)
Private collection

156 **Neckpiece, 2017**
Gold, moonstone
6 ½ × 7 in. (16.51 × 17.78 cm)
Private collection

Selected Reading

Primary Sources

Schon, Marbeth. "An Interview with Betty Cooke," June 13, 2001. www.modernsilver.com/ BETTYCOOKE.html (site discontinued).

Yager, Jan. Oral history interview with Betty Cooke, July 1–2, 2004. Smithsonian Archives of American Art.

Secondary Sources

"84 Contemporary Jewelers: American Jewelry Designers and Their Work." *Design Quarterly* 33, no. 18 (1955): 14–30.

"American Jewelry." *Design Quarterly* 45–46 (1959): 10–11.

American Craftsmen's Educational Council. *Designer Craftsman U.S.A. 1953*. New York: American Craftsmen's Educational Council, 1953, fig. 204.

Cooke, Betty. "Jewelry Designed by Betty Cooke." *Arts and Architecture* 66, no. 4 (April 1949): 32.

Doss, Margot. "Designing Young Woman." *Baltimore Sun*, October 23, 1949.

Falino, Jeannine, ed. *Crafting Modernism: Midcentury American Art and Design*. New York: Abrams and Museum of Arts and Design, 2011, 124, 133–34, 276.

Franke, Lois E. *Handwrought Jewelry*. Bloomington, Ill.: McKnight & McKnight, 1962, 18, 113, 125.

Gentille, Thomas, William Sayles, and Shirley Sayles. *Step-by-step Jewelry: A Complete Introduction to the Craft of Jewelry*. New York: Golden Press, 1968, 64.

Greenbaum, Toni. "Betty Cooke." In *Messengers of Modernism: American Studio Jewelry 1940–1960*, edited by Martin Eidelberg. Montreal and Paris: Montreal Museum of Decorative Arts in association with Flammarion, 1996, 122–23.

Greenbaum, Toni. "Women Jewelry Designers." In *Women Designers in the USA, 1900–2000: Diversity and Difference*, edited by Pat Kirkham. New Haven and London: Yale University Press and Bard Graduate Center for Studies in the Decorative Arts, 2002, 207, ill.

Ilse-Neuman, Ursula. *Inspired Jewelry from the Museum of Arts and Design*. New York: Museum of Arts and Design, in association with ACC Editions, Woodbridge, England, 2009, 35, ill.

Ilse-Neuman, Ursula. *Jewelry of Ideas: The Susan Grant Lewin Collection*. New York and Stuttgart: Cooper Hewitt, Smithsonian Design Museum and Arnoldsche Art Publishers, 2017, 14, 138.

L'Ecuyer, Kelly H. *Jewelry by Artists in the Studio, 1940–2000*. Boston: Museum of Fine Arts, Boston, 2010, 39, 83, 88, 213–14, figs. 53, 180.

Lewin, Susan Grant. *One of a Kind: American Art Jewelry Today*. New York: Harry N. Abrams, Inc., 1994, 37, ill.

Lupton, Ellen. "Exhibition in Print: 'Framing: The Art of Jewelry.'" *Metalsmith* 27, no. 4 (Fall 2007): 8, 56.

Martin, Richard. *Design–Jewelry–Betty Cooke*. Baltimore: Maryland Institute, College of Art, 1995.

Martin, Richard. "Design–Jewelry–Betty Cooke." *American Craft* 55, no. 6 (December/January 1996): 30–33.

May, Stephen. "Betty Cooke: Modern Jewelry Pioneer." *Antiques and the Arts Weekly*, June 11, 2013. Accessed December 6, 2019. www.antiquesandthearts.com/web-6-14-13-lead-betty-cooke.

Metcalf, Bruce. "Design—Jewelry—Betty Cooke." *Metalsmith* 15, no. 4 (Fall 1995): 40.

"Modern Jewelry under Fifty Dollars." *Baltimore Museum News* 13 (December 1949): 5–6.

Neyman, Bella. "The Unstoppable Betty Cooke." *Metalsmith* 37, no. 5 (Fall 2017): 45–49.

Nordenfjeldske Kunstindustrimuseum. *Årbok 1953*. Trondheim, Norway: I kommisjon hos F. Bruns bokhandels forlag, 1953, 25, fig. 13.

Rousuck, J. Wynn. "Jewelry." *Baltimore Sun*, December 8, 1974.

Schon, Marbeth. *Modernist Jewelry 1930–1960: The Wearable Art Movement*. Atglen, Pa.: Schiffer Pub., 2004, 46–50, 120, 187, 259, ill.

Schon, Marbeth. *Form & Function: American Modernist Jewelry, 1940–1970*. Atglen, Pa.: Schiffer Pub., 2008, 3, 18, 19, 32, 44, 46, 52, 63, 126, 127, 243, 248, 250.

Shaykett, Jessica. "Betty Cooke: Art + Work." *American Craft* 71, no. 5 (October 2011): 80.

"The Smartest Leather Designs are the Simplest to Make." *Woman's Day*, February 1956, 77–83.

Wallance, Don. "Betty Cooke, Baltimore, Md." In *Shaping America's Products*. New York: Reinhold Publishing Corporation, 1956, 162–63.

Wharton, Carol. "Exhibit Notes." *The Sun, Baltimore Sunday Morning*, November 16, 1947.

Wharton, Carol. "Exhibit Notes." *The Sun, Baltimore Sunday Morning*, December 12, 1948.

Wharton, Carol. "Pathfinder in Jewelry." *Baltimore Sun*, December 4, 1949.

Winebrenner, Kenneth. *Jewelry Making as an Art Expression*. Scranton, Pa.: International Textbook Company, 1953, figs. 261, 269, 329.

Wolf, Toni Lesser. "Betty Cooke: Total Design in Jewelry." *Metalsmith*, Spring 1989, in association with Ganoskin. Accessed December 6, 2019. www.ganoksin.com/article/betty-cooke-total-design-jewelry.

"Woman's Day Collector's Craft Book, Twelfth in a Series, Sterling Silver Jewelry." *Woman's Day* (April 1958): 72–77.

Woman's Day Gift Book. New York: Woman's Day, Inc., 1957, 29–31.

Index

Page numbers in *italics* indicate illustrations

Museum Collections
With holdings of works by Betty Cooke

Baltimore Museum of Art

Cooper Hewitt, Smithsonian Design Museum

Cranbrook Art Museum

Montreal Museum of Fine Arts

Museum of Arts and Design

Museum of Fine Arts, Boston

Museum, Rhode Island School of Design

University of Arizona Museum of Art

Library of Congress Cataloging-in-Publication Data

Names: Falino, Jeannine J., author. | Walters Art Museum (Baltimore, Md.), organizer, host institution.

Title: The circle and the line : the jewelry of Betty Cooke / Jeannine Falino ; edited by Eleanor Hughes.

Description: Lewes : GILES ; Baltimore, MD : The Walters Art Museum, 2020. | Includes bibliographical references and index. | Summary: "Betty Cooke (b. 1924) is an internationally recognized jeweler and Baltimore icon. In the course of a career that has spanned over seven decades, her work has won awards, representation in museum collections, and the devotion of loyal patrons. This beautifully illustrated catalog accompanies Betty Cooke: The Circle and the Line, the first retrospective museum exhibition to explore the themes and varieties in Cooke's design practice, beginning with her earliest work in the 1940s and '50s. The necklaces, pins, rings, bracelets, and earrings shown and discussed here are drawn from private lenders and museums as well as from Cooke's own collection. They reveal not only the spare, modernist aesthetic for which Cooke is known but also the wit, humor, and deeply personal associations conveyed in her jewelry"-- Provided by publisher.

Identifiers: LCCN 2020019271 | ISBN 9781911282778 (hardcover)

Subjects: LCSH: Cooke, Betty, 1924---Exhibitions.

Classification: LCC NK7198.C617 A4 2020 | DDC 739.27092--dc23

LC record available at https://lccn.loc.gov/2020019271

This catalog accompanies the exhibition
Betty Cooke: The Circle and the Line
The Walters Art Museum, Baltimore
September 26, 2020–January 3, 2021

The Walters Art Museum
600 N. Charles St.
Baltimore, MD 21201
www.thewalters.org

Julia Marciari-Alexander,
Andrea B. and John H. Laporte Director

Eleanor Hughes, Deputy Director for Art & Program

Ruth Bowler, Director of Imaging,
Intellectual Property, and Publications

First published in 2020 by GILES
An imprint of D Giles Limited
66 High Street
Lewes, BN7 1XG
UK
gilesltd.com

ISBN 978-1-911282-77-8

Where multiple dimensions are given, height precedes width precedes depth.

Copyedited and proofread by Sarah Kane

Designed by Ocky Murray

Printed and bound in Slovenia

Photography on behalf of the Walters Art Museum by Ariel Tabritha. Cats. 6, 13, 31, 51, 98, 133, 134, 137, 138, 139, 145, 146 and 149 by John Dean.

Cover: cat. 111 (detail); frontispiece: cat. 132 (detail); p. 4: cat. 107; p. 5: cat. 19; p. 6: cat. 142; p. 9: cat. 23; pp. 12–13: cat. 89; pp. 16–17: cat. 81; p. 45: cat. 18; p. 46: cat. 104; p. 47: cat. 140; pp. 48–49: cat. 120 (detail); p. 57: cat. 74; pp. 64–65: cat. 151 (detail); pp. 74–75: cat. 98; pp. 80–81: cat. 121 (detail); pp. 86–87: cat. 150 (detail)